Unresolved Stress

Thirsting For Peace

Unresolved Stress

Thirsting For Peace

TATE PUBLISHING & *Enterprises*

TATE PUBLISHING
& Enterprises

Tate Publishing is committed to excellence in the publishing industry. Our staff of highly trained professionals, including editors, graphic designers, and marketing personnel, work together to produce the very finest books available. The company reflects the philosophy established by the founders, based on Psalms 68:11,

"The Lord Gave The Word And Great Was The Company Of Those Who Published It."

If you would like further information, please contact us:
1.888.361.9473 | www.tatepublishing.com
TATE PUBLISHING & Enterprises, LLC | 127 E. Trade Center Terrace
Mustang, Oklahoma 73064 USA

Unresolved Stress: Thirsting for Peace

Unless otherwise noted, scripture quotations are taken from the *New American Standard Bible* ®, Copyright © 1960, 1962, 1963, 1968, 1971, 1972, 1973, 1975, 1977, 1995 by The Lockman Foundation. Used by permission. All rights reserved.

Scripture quotations marked "KJV" are taken from the *Holy Bible, King James Version*, Cambridge, 1769. Used by permission. All rights reserved.

Scripture quotations marked "NIV" are taken from the *Holy Bible, New International Version* ®, Copyright © 1973, 1978, 1984 by International Bible Society. Used by permission of Zondervan Publishing House. All rights reserved.

The opinions expressed by the author are not necessarily those of Tate Publishing, LLC.

This book is designed to provide accurate and authoritative information with regard to the subject matter covered. This information is given with the understanding that neither the author nor Tate Publishing, LLC is engaged in rendering legal, professional advice. Since the details of your situation are fact dependent, you should additionally seek the services of a competent professional.

Book design copyright © 2007 by Tate Publishing, LLC. All rights reserved.
Cover design by Chris Webb
Interior Design by Janae J. Glass

Published in the United States of America

ISBN: 978-1-5988687-1-5

07.01.18

To Darlene,
my wife and precious friend.

Acknowledgements

I want to thank the many teachers and pastors through whose faithfulness and insight into the Word of God, my thoughts have been greatly influenced; my son, Tim, for his technical help, and the many kind people at Tate Publishing for their professionalism, encouragement, and help in preparing this manuscript.

Contents

Introduction

"For the brokenness of the daughter of my people,
I am broken. I mourn; dismay has taken hold of me.
Is there no balm in Gilead? Is there no physician there?
Why then has not the health of the daughter of
My people been restored?" (Jeremiah 8:21–22)

If there's one thing I know, it's people. Being a doctor is a great privilege. It allowed me an unusually close view of the human condition. People tell their doctors things. They share their secret fears, hurts and guilt—I've seen the lives of people up very close.

As a primary care physician, I see the same people over and over again. I've seen the results of their ideas and actions used in the marketplace of life. I've seen what works and what doesn't.

Having worked in the same city with essentially the same group of patients, I've witnessed the course of many lives over a considerable period of time. During these same years I've had the privilege of teaching the word of God in adult Sunday school. I've seen, in scripture, information about the ways things are and the way things ought to be. What I've read in God's Word, I've seen reliably duplicated in the lives of people.

Seeing, in such detail, the brokenness that results from

living life apart from God and knowing the truths revealed by God in His word, I feel compelled to share what I've seen, heard, and know.

In II Kings, chapter 7, four lepers found themselves sitting outside the gates of a city under siege. Because of the blockade, the people inside the city were starving. Suffering, pain, and death were everywhere. The lepers decided to go the camp of the enemy and beg for mercy. When they got there, they found the enemy had fled, and in such a hurry that they left behind all kinds of clothes, treasures and, best of all—they left behind all kinds of food. The lepers went from tent to tent, feasting and enjoying their new found bounty. But in the middle of their feasting (verse 9), they remembered what was happening in the city. They remembered that others were still in the city living in slavery, and said to each other, "We are not doing right. This day is a day of good news, but we are keeping silent."

When you know something that can bring freedom to those who are suffering, it's wrong to keep silent. So I share what God has allowed me to see and know in the hope that God will use it to bring healing and freedom to some lives.

So, let's clear our minds and consider our ways.

Part I

Preparation

I

Clear Your Mind

"*Therefore, prepare your mind for action . . .*"*I Peter 1:13 NIV*

I've seen a growing epidemic over the past three decades of practicing medicine. It's something like the one that devastated the civilized world in the 1300's. Like the plague, this epidemic seems contagious and is increasingly widespread. Though not as quickly, this epidemic causes broken bodies and broken lives, and like the Black Death, treatment of this plague seems ineffective.

The treatment of the plague was both varied and ineffective because the underlying cause wasn't known. Today, the treatment of stress is both varied and ineffective for the same reason. It's my hope to offer some elucidation of the real cause as well as effective treatment.

However, to understand anything, we need clear minds—minds that work. One of the problems with the stressed state is that it causes cloudy thinking. It's difficult to focus; it's hard to concentrate. The ability to assess, judge, and come to conclusions is impaired. Before we can

use our minds to consider the real causes and effective treatment of stress, we have to clear our minds.

So many people are in the same condition Martha found herself in, in Luke chapter 10. There the text describes Martha as being "distracted." The Greek word is *perispao:* to be driven about mentally; over occupied. She was worried and bothered by "so many things" (Luke 10:41). Sound familiar? Do you find yourself distracted, over occupied, bothered and/or worried by a lot of things? How is your mind working?

To clear our minds, we need to use right thinking. Right thinking (thinking based on truth) works. Wrong thinking (thinking based on error) doesn't. In my experience, there are five very common errors in thinking that result in distracted minds; minds that don't work well; minds with which we won't be able to think through these issues. Here are the five errors:

Erroneous Thought #1: I can and should fix everything
There are many things that mean a lot to us: loved ones, health, jobs, finances, etc. Most of these issues are issues over which we have little or no control. But our secular culture celebrates and deifies humanity. Our culture tells us that, if we put our mind to it, we can do anything, fix anything. So, believing this, we try to fix our jobs, our kids, our illness, and our money problems. We try and try and try and try, but we keep failing, and in the process we get stressed and distracted. Why? Because this cultural concept is wrong. There are some things that are just impossible for people to accomplish (Matthew

19:26). There are some things we just can't do. There are some things—many things, most things—we just can't fix. Some things only God can do. Some things only God can fix (Luke 1:37). Remember, there is a difference between what we care about and what we have control over. For example, we'd be bad people if we didn't care about our children but we'd be foolish people if we think we have control over them.

So . . . don't obsess about things over which you have no control.

Erroneous Thought #2: I can control my future or at least give some certainty to it.
The thought that somehow we can control our future is a wrong thought. It is in error and therefore can't work, yet people waste their lives trying to make tomorrow certain. If we plan enough, work enough, or spend enough we can get control; but life is filled with uncertainty. Life itself is uncertain. Our plans and our tomorrows happen only if God is willing (James 4:13–17).

So . . . don't obsess about tomorrow. There's enough trouble today (Matthew 6:34). Just make it 'til supper. Live each day as it comes—each day is a precious gift from God. Don't waste them worrying about things over which we have no control. Live in today; don't waste today. Do something good today.

Erroneous Thought #3: I am infinite. I have no limits.
If asked, most of us would deny having such thoughts, yet we act as if believe this. While we may recognize there are

things we are unable to do, we know there are plenty of things we can do, and we think we must do them all.

This too is an error in thinking. There is an infinite God but no infinite people. We are all finite. We have limits. We have to set limits. If we're doing too many things, it's our own fault. Other people will let us do whatever we're willing to do until we drop, then they'll find someone else to do it. So don't blame other people.

So . . . set limits. Say no. It's not a sin to refuse to do everything. There's a difference between what we want to do and what we can do. Only God can do everything. Only God is infinite. You're not God.

Erroneous Thought #4: I must keep pushing. I can't stop.
Our culture tells us that not only must we do everything, control everything, and fix everything, but we can never stop. We have to keep pushing; we have to keep chasing after things—though usually people aren't really sure what they're chasing. This thought is also in error, and therefore doesn't work. When people never stop, they run out of physical and emotional energy. When the ship of our lives is constantly out on the high seas, we get battered and broken. People need to get off the high seas regularly and pull into some safe harbor in order to get ship shape.

So . . . don't keep pushing. Take breaks. Jesus took breaks (Matthew 14:22–23). What makes you think you don't need to?

Erroneous Thought #5: I can control my mind and emotions myself. I don't need help.
In our culture, self is god. There's nothing we can't fix;

nothing we can't control. We don't need limits and we don't need breaks. We can do anything if we want it badly enough and try hard enough. If we have generalized anxiety, we can control it. If we have panic attacks, we just have to try harder and we'll conquer them. If we're depressed, we can figure it out ourselves. That all sounds nice, and it's really inspiring, the only problem is it's a lie.

All creation is flawed (Romans 8:20–22). No part of our bodies is perfect. Nothing here is the way it was intended to be. Joints are imperfect, hearts are imperfect, and brain chemistry is imperfect. Some of us need insulin because our pancreases are flawed. Some of us need ibuprofen because our joints are flawed. Some of us need medication for anxiety and/or depression because our brain chemistry is flawed. Brain chemistry needs to be working right in order for our brains to work, but we can't will our brain chemistry to change. People don't wake up one morning and say "I think I'll increase my brain serotonin today." We can't do it. That's what pills are for. Taking medications for anxiety and/depression is no sin.

So . . . if medication is needed, take it.

Once we've cleared our minds of thoughts that are in error, once we've freed ourselves from the lies of our culture, our minds can then address the task at hand. With clear minds, we can consider the issues before us.

II

Consider Your Ways

*"Let us examine and probe our ways,
and let us return to the Lord."*
Lamentations 3:40

If we're constantly trying to fix unfixable things in our lives, we won't be able to think straight. If we're obsessed with controlling the future, our minds won't work well. If we never set limits or take breaks, we'll be distracted, worried and bothered.

Despite what some in our culture say, the Christian faith encourages thought. In fact, it requires thought. We're instructed to think, consider, ponder, meditate, and choose—all of which require a clear mind.

In the Old Testament, the prophet Haggai tells the people of Israel to "Consider your ways!" (Haggai 1:5, 7). Solomon says "ponder the path of your feet," (Proverbs 4:26). Think about your ways; think about your path. Where is this road taking you? How are you going to get free of all this and prevent it from happening again?

That's what we're going to talk about in the next chapters. Where has stress taken us? How did we get so stressed and how can it get fixed?

So get alone to some quiet place. Say no to all those demands of life at least for a little while. Stop trying to control everything. Stop trying to fix everything and consider your ways.

Ponder the path of your feet.

Part II

The Problem

III

Where Has it Taken Us?

The Results of Stress (Shebar)

"Woe is me, because of my brokenness!
My wound is incurable. . . ."
Jeremiah 10:19

People get broken when stress is unresolved.

There's a difference between stress and unresolved stress. While stress in our culture is virtually unavoidable, it is prolonged or unresolved stress that hurts people. The stressed state is a physiologic state in which too much adrenaline and too much cortisone is produced. As a result, heart rate and blood pressure rise, blood sugar increases, blood is shunted away from major organs and diverted to the muscles, and blood clotting increases. For short periods of time these changes can be adaptive (fight or flight), but when prolonged (when the stressed state is not resolved) great harm is done.

According to Isaiah 59:7–8, the person without peace heads on a path toward what in Hebrew is called, shebar. Unresolved stress leads to brokenness; shebar: fracture, crush, break into pieces, shatter, ruin, rend violently. Now stop and think about it. What stress in your life has

remained unresolved? What in our lives has gotten broken, shattered, or ruined because of continuing stress?

1. Unresolved stress can harm parts of our body:
- Skin: causing hives, eczema, and psoriasis
- Muscular-skeletal: causing headaches, neck pain, back pain, jaw pain, and the worsening of arthritis
- Gastrointestinal: causing ulcers; colitis; irritable bowel syndrome
- Endocrine: causing worsening of diabetes
- Cardiovascular: causing skipping of the heart; high blood pressure; fainting; heart attacks; strokes

Unresolved stress can ruin our bodies.

2. Unresolved stress can harm our mental health.

Our brains produce chemicals called neurotransmitters (serotonin, dopamine, and norepinephrine). The amount we can produce is genetically determined. We can produce only a certain amount. Unresolved stresses in our lives suck these chemicals out of our brains, so to speak. When the demands exceed the supply, people become depleted of neurotransmitters and then become anxious and/or depressed. Sleep patterns are disturbed, energy levels are diminished, motivation is gone, and everything becomes a great chore. Things that we once looked forward to doing become a burden. We have to force ourselves to do everything and anything. We feel helpless and eventually even hopeless.

Unresolved stress can ruin our mental health.

3. Unresolved stress can harm our relationships.

When stress in our lives is not resolved, we can get stuck in certain conditions, attitudes, or emotions: worry, bitterness, guilt, self-loathing, exhaustion, sense of isolation, chaos, and/or a sense of futility. In these states, we're not fun people. All this hurts our relationships with others.

When things get broken, they hurt. When things are shattered, they cause pain. Broken bodies hurt. Broken emotions are painful. Broken relationships cause pain. Stress that's not handled causes great brokenness and great pain.

Think it over. Is some part your body broken? Are your emotions shattered? Are your relationships in ruin? Are you in pain? How did you get there? Is there some stress that hasn't yet been resolved? If your answer to any of these questions is yes, that is not good. So now what do we do?

IV

How Did We Get There?

The Reason for Stress

*"Cursed is the man who trusts in mankind
and makes flesh his strengthand whose heart turns from the Lord
For he will be like a bush in the desert."Jeremiah 17:5–6*

"Before destruction the heart of a man grows haughty." (Proverbs 18:12)

Think about it. Why has our stress remained unresolved? Perception, alarm, resistance, and exhaustion . . . these are the steps that lead to stress according to those who study it. We'll look at these four steps and try to figure out why people get stressed and stay stressed.

A. Perception

Ponder this. What kind of place is this world? Some say it's a big, wide, wonderful world we live in. Some popular music implies something else. There's a line in the song "Old Man River" that says "I get weary and sick of tryin. I'm tired of livin' but scared of dyin . . ." The orphans in the musical, *Annie* tell us "It's a Hard Knock Life." The theme from the TV show *Monk* says, "People think I'm

crazy 'cause I worry all the time. If you paid attention, you'd be worried too."

It doesn't take too long for someone who's been around for a while to figure out what kind of a place this world is. Oppressive jobs, unreasonable, unfeeling bosses, mounting debt, failing health, injustice, rotten relationships, messed up lives, unending demands, and confusing dilemmas. The world is a tough place. This is consistent with Christian thinking.

"Yet man is born to trouble as surely as sparks fly upward," (Job 5:7 NIV)

"In the world, you shall have trouble . . ." (John 16:33)

"Beloved, do not be surprised at the fiery ordeals among you which comes for your testing as though some strange thing were happening to you;" (I Peter 4:12)

B. Alarm

In the middle of all this trouble, we often know something is wrong with us. We just don't know what it is or how to fix it. We can tell something is wrong in several ways.

- What comes out of our mouths tells us something is wrong with us. Our words are negative and, worse than that, they're hurtful. What we say tears other people down and hurts other people.

- We can tell something is wrong by our behavior—it's destructive. We frequently tear down and hurt people and ourselves by the things we do. What's worse is we're stuck. We keep doing the same destructive things and with the same destructive attitudes.

- And we can tell something is wrong with us by the way we feel. We feel like things are out of order. Things aren't the way they're supposed to be, and we feel like we have no peace. By our words, by our behavior, and by our sense of disorder, we know something is wrong. We just don't know what it is. So what's really wrong? What's really the problem?

There is a principle in medicine: we must treat the disease, not the symptoms. For example, if a patient comes to us with a cough from tuberculosis, and we give them cough syrup, we are not treating the real problem. They may feel better, the cough might actually get somewhat better, but the disease will go on to consume them. Gall stones produce lots of gas, but doctors shouldn't treat gall bladder disease with pills to make patients burp. It'll feel better to burp, but one day the gall stones might get stuck, infected, and cause serious harm. And we can't treat stress by treating just the symptoms. It might feel better to have relaxed muscles and slowed heart rates, but the underlying condition will go on to produce great harm.

So where's the problem? What's the underlying condition that needs addressing? It is the heart. The heart is the thing. That's where the conflict lies.

Is there such a thing called "the heart"? Is there really? What do you think? Are we just a random blob of protoplasm with neurotransmitter filled brains and internal biofeedback systems? Is there anything more to us then this?

Where is it that we love our children? What part of us generates that feeling? Is this simply a biochemical process? Is it some yet to be discovered section of our brain that makes us love? Intuitively, we know this isn't true. There is a deeper part of us. There is an inner person. There is something called the heart. It's where we love our children.

The heart is the repository of our deepest needs and longings. It is the battleground of our greatest conflicts; the wellspring of our speech and our behavior. If there's something wrong with our words it's just a symptom of a troubled heart (see Matthew 12:33–34). If our behavior is hurtful, then we need to check our heart (see Matthew 15:17–20).

So what's going on? The heart, the inner person, has longings and needs. The heart longs for safety, justice, rest and direction. The heart needs forgiveness, self-esteem, love and meaning. These aren't just casual, superficial needs, but deep yearnings, as if our souls are thirsting. We've seen in this world that these needs of our soul are constantly being threatened. We need to feel safe but there's trouble in the world. We long for justice, but injustice is everywhere. Our hearts thirst for guidance but confusion and temptation are all around us. There arises a dissonance, a mingling of clashing sounds deep within us. We long for but can't have, we yearn, but can't find. We thirst but there's no water to quench our thirst and so our inner person, our heart, feels stressed.

It's as if fiery arrows are being thrown at our needs filled hearts and we thirst for answers.

C. Resistance

"Pride goes before destruction (*shebar*)
And a haughty spirit before a fall." (Proverbs 16:18 NIV)

"Before destruction (*shebar*) the heart
of man is haughty." (Proverbs 16:18 NAS)

Unresolved stress comes from believing two lies that are as old as mankind itself. When our hearts, our inner persons are proud we will say to ourselves:

- We can fix this thing ourselves. We are in control. We can be like God (Genesis 3:5). We will follow our own ideas (Isaiah 65:2b). When life throws us some problem that causes our insides to thirst, we'll just quench that thirst ourselves. We can do it.

- We don't need God for this. We'll forget about God (Psalm 10:4). God is irrelevant.

"For My people have committed two evils: They have forsaken Me, the fountain of living waters, To hew for themselves cistern, Broken cisterns, That can hold no water." (Jeremiah 2:13)

Since lies don't work, the stress continues. Since we don't have the capacity to put all the issues of life in order, the clashing sounds of our hearts' needs and the demands of reality continue. When we cut ourselves off from God, it's like we're in a desert. Our hearts are thirsting. We have needs but we can't quench our thirst. We live in a dry and weary land where there is no water.

> Thus says the Lord,
> Cursed is the man who
> Trusts in mankind
> And makes flesh his strength,
> And whose heart turns away
> From the Lord.
> For he will be like a bush
> In the desert.
> And will not see when
> Prosperity comes,
> But will live in stony
> Wastes in the wilderness,
> A land of salt without
> Inhabitant. (Jeremiah 17:5–6)

D. Exhaustion

When stress remains unresolved, we get stuck in the results. When our heart can't find safety, we get stuck in fear and worry. When we can't find justice, we get stuck in bitterness. Lack of resolution leads to enslavement and enslavement leads to brokenness (see chapter one).

Now we can see the real issue—our hearts. They are thirsting with needs. We're afflicted by the issues of life and captured by the lie that we can do it all ourselves. We're then enslaved by the results of our lack of resolution; afflicted, captured, enslaved, and finally broken. It's a rough world. Problems attack the deepest needs of our hearts. We try to fix them ourselves, but it doesn't work. The dissonance goes on. Here's the reason the health of the people has not been restored. This is why there is so much unresolved stress.

But is there no balm in Gilead? Is there no physician there? Is there no remedy?

Now we're reminded of the prophesy of Isaiah, referring to Jesus and all who follow after Him:

> The Spirit of the Lord God is upon me,
> Because the Lord has anointed me
> To bring good news to the *afflicted;*
> He has sent me to bind up the *brokenhearted,*
> To proclaim liberty to the *captives*
> And freedom to *prisoners.* (Isaiah 61:1)

V

What Do We Do?

The Remedy for Stress

Shalom
"Blessed is the man who trusts in the Lord
And whose trust is in the Lord.
For he will be like a tree planted by the water,
That extends its roots by a stream
And will not fear when the heat comes;
But its leaves will be green,
And it will not be anxious in a year of drought
Nor cease to yield fruit."
Jeremiah 17:7–8

"And they heal the brokenness of the daughter of My people superficially saying, 'Peace, peace.' But there is no peace." (Jeremiah 8:11)

I once conducted an informal survey of my patients over a period of months asking them, if there was one thing that I could do for you, one thing that I could give you, what would it be? Overwhelmingly, the answer was peace. People just want to have some peace. Usually they weren't sure what it was and almost never knew how to find it, but they did know they wanted it.

According to Jesus, in John 14:27a, there are two kinds of peace. "Peace I leave you; My peace I give to you; Not as the world gives, do I give to you.. . . ."

There is a peace that is offered by the world apart from any acknowledgment of God. There is another kind of peace, the peace that Christ offered. Let's look at both kinds of peace.

A. Peace the World Offers

"And they heal the brokenness (*shebar*) of
the daughter of My people superficially Saying
'peace, peace'But there is no peace. (Jeremiah 8:11)

In our culture, many feel God is irrelevant. Therefore the quest for peace must occur apart from God—people have to find or make their own. There are literally thousands of stress management techniques, courses, organizations, web pages, and seminars. According to Jeremiah, all these approaches sound good. They appear good but they don't really work.

These approaches fall into three categories. Apart from God, here's how we can control the stresses of life:

- Work on the circumstance. Don't drift into troublesome . . . situations.

- Work on the response. Learn to reduce your emotional response to stress.

- Work on the results. Relax your body with soothing sounds of nature or meditation or message techniques.

The problem with all these approaches is described in the book of Ezekiel 13:10–12. These approaches to stress management are like repairing a wall by painting it with

whitewash. This helps slightly; the whitewash can help hold the wall together a little and it looks good, but the problem comes when something big comes along. When the hail or wind or rain is bad enough, the wall will fall.

These approaches to stress management (the ones that don't take God into account) work, but only slightly. They heal but only superficially. They promise peace but there is no peace. All it takes is one big enough thing and the wall painted with whitewash will go crash.

The problem with contemporary stress management techniques and what they lack is further illustrated by the story of Daniel in the lion's den.

We may recall that in the Old Testament, Daniel found himself in a den of hungry lions. We may feel like that sometimes. Some of us may be feeling like that right now. We feel like we're surrounded by hungry, furious lions and there is no way out. So let's try to apply the principles of contemporary stress management to Daniel's situation.

We could advise Daniel not to drift into troublesome situations. However, the lions weren't his idea nor were they anything he had control over. That's the way it often is with stress. Health problems, financial issues, an awful boss, or an unfaithful spouse occur unforeseen and beyond our power to prevent.

We could advise Daniel to learn to reduce his emotional response, but those lions have very big teeth. It's a real danger. Sometimes it's appropriate to feel stressed.

Finally, maybe a nice tape of bird calls would help relax Daniel. He seems so tense down there with those lions. Now, there's nothing wrong with relaxation tapes. They

do help, but only slightly. They help the result of our stress (tense muscles), but the cause remains. This is like treating tuberculosis with cough syrup; it will help the symptom but not the disease. Daniel doesn't need a tape as much as he needs someone to help him with the lions.

So what's missing?

In the Old Testament, I Kings 18, there was a contest. It was between the prophets of the god, Baal, and Elijah. These prophets of Baal needed the help of Baal to win the contest. So they called out to Baal, they cried out to him. But the Biblical text says, " . . . but there no voice, no one answered and no one paid attention," (verse 29).

Perhaps we've been, or are in such a circumstance. In our need, in our stressed state, we've called out to whatever it is that we trust in the most—man's ideas, man's ability, our own influence, our wealth, or our intellect. But it seems like no one hears, no one answers, and no one pays any attention. These things we trust in are called, in the Bible, false trusts. We may have made them into our gods—false gods. But false gods can't hear or see or speak or feel (Psalm 115:4–8). They are described to be like scarecrows in a cucumber field (Jeremiah 10:5). They can't do any harm nor can they do any good. And why not? Why can't false gods help us? Because they're dead!

What people really need in times of dissonance, when reality attacks the basic needs of our hearts, is a God who can hear and see and speak and feel and come to us and help us and deliver us. We need a God who is alive. We need the living God. This is what the stressed heart is thirsting for. "As the deer pants for the water brook, so my

soul pants for Thee, O God. My soul thirst for God, the living God . . ." (Psalm 42:1–2; see also Psalm 84:2)

Our hearts were created with a need for the Living God. (Psalm 63:1) Nothing else will quiet the inner dissonance. Without the Living God, the mingling of clashing sounds will not stop.

> The King spoke and said to Daniel, 'Daniel, servant of the Living God, has your God whom you continually serve been able to deliver you from the lions? Then Daniel spoke to the King, 'O King, live forever! My God sent His angel And shut the lion's mouths and they have not harmed me . . . (Daniel 6:20–22)

People need God. People need the living God.

B. Peace (Shalom)

Life is filled with problems and some of these problems are like the lions in the book of Daniel. We get thrown among them unexpectedly; they're very big—bigger than we are. It's hard to ignore them and we know they can hurt us. How can we tame these lions of life? How can we find peace in the lion's den?

The attempts at peace apart from God tell us to learn to ignore the lions, which is impossible; or don't get upset about the lions, which is irrational; or just learn to relax when confronted by lions, which is superficial. The world says, "Peace, peace," but there is no peace.

There is another kind of peace and it comes from the living God. Let's look at what is this peace: what does it do, and how do we get it.

1. Peace: What is it?

We define peace in fundamentally negative terms. We say peace comes from the ridding of negative influences. If only we could get rid of the lions, we'd have peace. If we have a bad job situation, finding a new job would give us peace. If we have money problems, winning the lottery would give us peace. If we have a difficult husband or wife. . . . well . . . we get the idea.

But the concept of *shalom* is not the ridding of negative influences or the absence of conflict (see 1Samuel 11:7 and Judges 6:11–26). *Shalom* in not the absence of trouble but rather it is the sense of order in the midst of trouble.

Even in the middle of troubles, people who have real peace have the sense that everything is in order . . . everything is as it ought to be.

2. Peace: What does it do?

In the chapters that follow, we're going to be talking about the lions we all face: troubles, injustice, the wrongs we've done, self-loathing, the demands of life, loneliness, confusion, and futility. All these issues threaten the basic needs of hearts. Phony peace tells our hearts we can get rid of all these issues; phony peace tells our hearts to not react. Phony peace tells our hearts to learn to relax, but the lions keep attacking. The needs of our hearts go unaddressed. We try to dig our own wells, but we remain thirsty. "Be anxious for nothing but in everything by prayer and supplication with thanksgiving let your requests be

made known to God. And the peace of God, which surpasses comprehension shall guard* your hearts and minds in Christ Jesus," (Philippians 4:6–7).

phroureo: to protect by a military guard: to prevent hostile invasion

Real peace protects our hearts and minds in the middle of life's troubles. Real peace puts a guard around our hearts even when the lions are stocking us.

3. Peace: How do we get it?

How does this happen? How can we have the sense that everything is in order when troubles and injustice are all around us? How can we feel that everything is as it should be in the middle of confusion and life's unending demands? What is this thing that will protect our hearts when we know the lions are hungry?

Real peace comes from three things: connection, knowledge, and submission.

A. Connection

Jeremiah 17 describes a bush in the desert and a tree planted by the water. The bush and the tree are similar to people in several ways. The bush and the tree have needs. They need water. It's not a casual need, it's an essential need. They can't prosper without water. They can't live without water.

People have needs. They have deep needs; essential needs, without which they can't function or prosper. So all living things have needs.

The bush and the tree lived in an environment hostile to their needs. In the desert, there is heat which increases

the demand for water. In the desert there is drought, which decreases the supply. So it is with people. We live in an environment hostile to our needs. Life often taps our supplies and turns up the demands. Sometimes it feels like an attack, like we've been struck with a flaming arrow or fiery dart. Illness, loss, loved ones gone wrong attack the needs of our heart. Injustice, the demands of life, chaos turn up the heat and we, like the bush or tree, get thirsty. Sometimes life hits us in a different way. It's doesn't feel like a sudden, violent attack but rather a constant, unrelenting heat; a constant, slow, sizzling sucking our hearts dry. Guilt can do that. Loss of our self esteem can feel like that. So can loneliness and emptiness. Whether it's an attack of fiery darts or an oppressive blanket of heat, the result is the same. We, like the bush and the tree, get thirsty.

What do we do when we're thirsty? There are two approaches. There is the bush approach and the tree approach. In life's heat and drought, we can choose to live like the bush. We can go it alone. We can declare God irrelevant and trust in ourselves or other people to meet our needs, to quench our thirsts. Like a bush in the desert, we can live our lives stubbornly and independently. We can fix it ourselves, address our own needs, quench our own thirst, quiet our own hearts . . . the only trouble is that this doesn't work. We find, when digging our own cisterns, that they are broken cisterns that don't hold water. We find this is a dry and weary land where there is no water. We remain thirsty. The need is not meet. The

stress continues. We become enslaved in the results of our failure and broken in bodies, emotions and relationships.

The other approach is the tree approach. Trees also live in a hostile environment. The flaming arrows are just as common. The summer heat is just as intense. The needs are just as real . . . the difference is connection. The tree is connected to the source. The tree is connected to the water. So when the heat comes, the tree doesn't have to worry. When the drought comes, there's still plenty of water. The tree still prospers.

So it is with people. The issue is connection. People can't live disconnected in a hostile environment. They'll get thirsty and stay thirsty. People can't live without God. We need connection to the source.

So . . . how does this happen? How do people get connected to the God—the source of their needs?

To get connected two things have to happen.

First, we have to have a change of mind. The word for this in Greek is *metanoia* which means a change of mind consequent to the after knowledge, indicating a regret for the course pursued and resulting in a wiser view of the past and the future. After knowledge is just that—figuring something out after it's all over. Looking backwards makes things clearer. Seeing the messes we've created helps us to see our mistakes and gives us "after knowledge." But repentance (*metanoia)* requires not only understanding what we have caused but also feeling badly about it. Trying to resolve life's issues on our own is never successful. Bad things happen. Innocent people get hurt. Rationally, it seems clear. . . . people can't live on their own. People

can't meet their own needs. People can't live without God. If we really think about it, this just makes sense.

But reason isn't enough. Connection with God requires more than reason. Blaise Pascal said, "Faith is different then proof, the latter is human. The former is a Gift of God." "It is the heart which perceives God . . . not the reason. That is what faith is; God perceived by the heart not by the reason." Connection to God requires God's gift of faith and faith requires seeing God with our hearts.

What is it that we need to see to receive this gift of God? What do we need to ask God? In the sixth chapter of the book of Isaiah, God revealed His nature to the prophet. God showed Isaiah what He was like. He showed Isaiah how distinctly unique He is, how holy He is. When Isaiah perceived the holiness of God with his heart, he perceived immediately he had a problem. He said, "Oh, no! I'm in big trouble. My mouth is unclean because my heart is unclean and, what's more, all these people around me have a problem too." When Isaiah saw God's holiness, he saw his own deficiency. . . . how his very nature separated him from God. But then God showed Isaiah the provision for his uncleanliness. And God has revealed the provision for our uncleanliness, but we need to see with our hearts. We need to see who Christ is with our hearts. We need to see that Jesus is the provision for our uncleanliness and separation . . . that God and sinners are reconciled because of Him. These are not acts of reason. These are acts of faith which is a gift from God. To get connected, we need God to grant us seeing hearts

(faith) so we can really perceive who we are; God is; and who Jesus is.

If we use our minds, we'll change our minds. If we ask for faith, God will change our hearts. No longer bushes in the desert, we'll become trees planted by the water. We'll be connected.

B. Knowledge

"Thou wilt keep him in perfect peace whose mind is stead on Thee." (Isaiah 26:3 KJV)

Repentance and faith are enough to give us peace with God, (Romans 5:1) but not enough to give us the peace of God. There are lots of people who genuinely trust in God and not themselves who are very stressed. There are lots of people who have much faith but not much peace.

To get through the maze of life unscathed by the flaming arrows or heat waves, we need more than repentance and faith. We need knowledge. We need to know God . . . not know about God but *know God*. We need to know who He is, what He's done, and what He's said.

Knowing God should be the goal of our lives (Philippians 3:7–8a).

What is it that we brag about? Jeremiah 9:23–24 says if we brag about anything, it shouldn't be our riches or our wisdom or our strength. If we boast, we should boast about our knowledge of God. There is no peace without knowing God.

C. Submission

"If only you had paid attention to my commandments, Then your peace would have been like a river . . ." (Isaiah 48:18)

Repentance, faith, and knowledge are still not enough to have real peace. If we have faith and have lots of religious knowledge but still are lacking in a sense of order in life, then we should ask who is umpiring our life. In a competition, an umpire does lots of things. If there is a close play or a question, it's the umpire who decides. If chaos breaks out in the game, it's the umpire who controls the game. And when all is said and done, it's the umpire who rules. Others can give an opinion, but the umpire's opinion is the only one that counts.

Colossians 3:15 says "And let the peace of Christ rule (*brabevo:* umpire; decide; determine; control; rule) your hearts. In the middle of life's battles, we need to be connected to God. We need to know who He is and what He's done and what He's said. But when the heat is turned up, we need to act as if we really know what we say we know and we need to behave as if we really believe what we say we believe. To really have peace, we need to do it God's way. We need to pay attention to His commands. Real peace requires obedience. For prideful people like all of us, that's really hard.

Now we're ready for the flaming arrows that life shoots at us. We're ready for the times of oppressive heat and don't kid yourself or be surprised (I Peter 4:12), they're going to come. . . but don't worry about the heat. We're connected.

Part III

The Specifics

I did an interesting experiment. Over the past years, each time I saw a person whose problem was primarily stress, I tried to write down the cause. Interestingly certain patterns developed. There seemed to be a limited number of situations, common to the human condition, which repeatedly resulted in unresolved stress.

These circumstances lent themselves to three categories: issues that primarily involved tomorrow; yesterday, and today.

Some of these circumstances hit like a flaming arrow causing a sudden thirst in us. Others envelope us like oppressive, unrelenting summer heat, causing a gradual withering thirst. In either condition, the result is the same—a thirsty, restless heart searching for some relief.

In the next eight chapters we'll look at these specific situations.

Tomorrow

It's amazing how many people get obsessed with tomorrow. We get stuck in the future. We constantly wonder about it, fret about it, and try to fix and control it. This is true both in good times and bad. In the good times, we fret about how we can keep things good. We know having a lot brings with it those who consume it (Ecclesiastes 5:11). So we become like the rich fool in Luke 12:16–21. In the good times we ask "What shall I do?" to keep what we have. How can we control tomorrow. Things are good and we need them to stay good. What shall I do?

It's even worse in the bad times. We wonder and fret about what the bad things will do to tomorrow. We obsess about fixing what is broken so that we can make the future safe and certain.

There's a lot wrong with this kind of thinking, but the main problem is that it's never going to happen. No matter how much we talk about it (Proverbs 27:1) and no matter how much we presume and pretend (James 4:13–14), tomorrow is never going to be certain. So how can we be safe if the future is unmanageable? How can we quench our thirst for security?

VI

Troubles

Megas Seismos

*"Nobody, as long as he moves about the chaotic currents
of life, is without troubles."*
Carl Jung

She was a very fit middle aged woman who came to me
complaining of inability to sleep. This was an unusu-
ally health conscious person. She swam three to four times
per week, played tennis twice a week, and owned a com-
pany involved in the health food industry. She was thin,
didn't smoke, and had a very low cholesterol. She was the
envy of all her friends. She was a cardiologist's dream but
she couldn't sleep.

I asked the question I often ask. "Life is stressful for all
of us but are there any unusual stresses going on lately?"
She became agitated and almost angry. She told me that
she had just seen a vascular doctor. She had developed
aching in her calves while playing tennis and her friends
told her she should see a specialist. After performing a
series of tests, the specialist told her she had severe gener-
alized cardiovascular disease. The arteries throughout her
body were hardening. Though she looked much younger

than her age on the outside, she was aging rapidly and prematurely throughout her body.

She was not a spiritual person. All her life she had trusted in man's knowledge and in herself. She couldn't understand how this could happen to her. She had trusted in her gods but they let her down. Now she cried out to them, but "there was no voice, no one answered, and no one paid attention." She was very stressed and couldn't find resolution. She wanted a sleeping pill but what she longed for was security. Her inability to sleep was just a symptom. Her heart was the real problem.a heart longing to be safe.

*(*To protect patient confidentiality, these stories are a blending of many different real situations but do not describe any one individual.)*

The real world is filled with troubles and, therefore, uncertainty. How can we have peace in such a world? Where can we quench our need for safety?

To answer these questions, we'll look at three issues: 1. What are troubles in life really like? (Luke 8:22–25) 2. What leads to getting stuck in fear, worry, and obsession with the future? 3. What can really free us and give us peace?

1. What are troubles in life really like?

> Now it came about on one of those days, that
> He and His disciples got into a boat, and He said
> to them, "Let us go over to the other side of the

lake." And they launched out. But as they were sailing along He fell asleep; and A fierce gale of wind descended upon the lake, and they began to be swamped and to be in danger And they came to Him and woke Him up, saying, "Master, Master, we are perishing!" And being aroused, He rebuked the wind and the surging waves, and they stopped, and it became calm And He said to them "Where is your faith?" And they were fearful and amazed, saying to one another, "Who then is this, that He commands even the winds and the water, and they obey Him?" (Luke 8:22–25)

One of the most common causes of stress is troubles. . . . usually some big trouble. They often hit us like a flaming arrow right in our heart; a heart filled with the need for security. They descend on us a lot like this storm described above. We begin our day, (launch out), usually a day like every other. We begin going about our business, (sailing along) and minding our own business. On most days, we pull back into the safety of our harbor and not much happens. But, not infrequently, we experience verse 23. "Descending" (*katabaino:* coming down unseen; suddenly; without warning*)* on us, we experience some "great storm." Matthew 8:24 translates this as *megas,* great in dimensions; and *seismos,* a shaking or commotion. Sometimes in life some great trouble comes down out of seemingly nowhere and hits us and shakes the foundations of our life. It can take many forms: a job loss; bad news from the doctor; a death; a financial disaster; a loved one gone wrong; a breaking of a relationship. Life is filled with *megas seismos.*

And, just like the disciples, we begin "to be swamped."

The thing is too big. It's bigger than we are. It fills us up completely. It surpasses our capacity. We begin to suffocate and feel we're no longer in control. Just like the disciples, we feel we're "in danger." We're no longer safe. Perception leads to alarm and our heart longs to be safe

2. Why do we get stuck in fear/worry/ and obsession with tomorrow?

As we've said, there's an awful tendency of man, both in good times (Deuteronomy 6:10–12) and in bad times to forget about God. In good times, we forget about God. We think we've done it on our own. In bad times, we forget about God. We think we have to fix it all on our own (Ruth 1:1; Jeremiah 2:13). So we act like bushes in the desert (Jeremiah 17:5–6). When we're thirsting for safety, we dig our own cisterns trying to quench our own thirst for safety. As we drink, we find the cisterns leak. They can't hold much water. The thirst goes on. We don't feel safe. The heart's need goes unresolved. The cycle repeats itself again and again and we find ourselves stuck in fear and worry. Then mired in fear and worry, we get broken. Our health breaks. Our emotions break. Our relationships break. I've seen this hundreds of times. People trying to fix things they can't fix; enslaved by worry; and getting sick.

3. What can free us and give us peace?

So what can help? What can free us and give us peace? It's clear troubles aren't going to end. It's clear we're always going to have the need for security. What can guard our hearts when *megas seismos* descend on us? What can quench a heart thirsting for safety in the middle of troubles?

When the next storm comes wrap your mind around this and wrap this around your heart:

A. God Is Sovereign

"He commands even the winds and the water, and they obey Him."

Sometimes, in the good times, we fool ourselves and think we are the ones running things. Like Nebuchadnezzar, we look around at what we have (Daniel 4:28–30) and pretend we did it and we're in charge. Often big storms remind us we're not really in control. When Nebuchadnezzar ran into some beastly problems (Daniel 4:31–33) and then God delivered him, he cried out:

. . . . I blessed the Most High and praised and honored Him who lives forever; for His dominion is an everlasting dominion. And His Kingdom endures from generation to generation. And all the inhabitants of the earth are accounted as nothing. But He does according to His will in the host of heavens and among the inhabitants of earth and no one can ward off His hand or say to Him, "What hast Thou done?" (Daniel 4:34–35)

In the middle of the great storms, we surround our hearts with the knowledge that God is still in control of everything.

"Who is the King of glory?

The Lord Almighty, He is the King of glory."

(Psalm 24:10)

B. God Is Near

". . . and they came to Him."

In the middle of your great storm, wrap your mind around the knowledge that God is near (Jeremiah 23:23)

To whom is God near?

"The Lord is near to the brokenhearted
And saves those who are contrite in spirit."
(Psalm 34:18)

The Lord is near to all who call upon Him,
To all who call upon Him in truth."
(Psalm 145:18)

How near is God?

- God is *above* us directing the affairs of men. "It is He who sits above the vault of the earth, and its inhabitants are like grasshoppers, who stretches out the heavens like a curtain and spreads then out like a tent to dwell in," (Isaiah 40:22).

- God is *beneath* us supporting us. "Do not fear for I am with you. Do not anxiously look about you, for I am your God. I will strengthen you, surely I will help you. Surely I will uphold you with My righteous right hand," (Isaiah 41:10).

- God is *before* us preparing our way. "The Lord your God who goes before you will Himself fight on your behalf just as He did for you in Egypt before your eyes," (Deut 1:30).

- God is *behind* us directing us. "And your ears will hear a word behind you, this is the way, walk in it whenever you turn to the right or to the left," (Isaiah 30:21).

- God is *beside* us helping us. "I have set the Lord continually before me. Because He is at my right hand I will not be shaken," (Psalm 16:8).

- God is *in* us giving us hope. "To whom God willed to make what is the riches of the glory of this mystery among the Gentiles which is Christ in you the hope of glory," (Colossains 1:27).

 "Am I a God who is near
 And not a God far off?"

 In the middle of the mess, we have lots of questions. We can answer them if we know God:

C. Where can I run?
God is our Refuge.

 God is our refuge and strength
 A very present help in trouble.

 Therefore we will not fear though the earth should change And the mountains slip into the heart of the sea; Though its waters roar and foam, Though the mountains quake at its swelling pride. (Psalm 46:1–3)

D. Who will protect me?
God is our Shield. "Our soul waits for the Lord; He is our help and our shield," (Psalm 33:20).

E. Who will help me fix this?

* God is our Helper.

 "I will lift my eyes to the mountains From whence shall my help come? My help comes from the Lord, Who made heaven and earth. He will not allow your foot to slip; He who keeps you will not slumber. Behold He who keeps Israel Will neither slumber nor sleep. The Lord is your keeper; The Lord is your shade on your right hand. The sun will not smite you by day Nor the moon by night," (Psalm 121:1–2).

F. Who will get me out of this?

* God is our Deliverer.

 "But I am afflicted and needy; Hasten to me, O God! Thou art my help and my deliverer," (Psalm 70:5).

Knowing all this is nice but it's not enough. . . . remember we have to act as if we know it and believe it. To have real peace, we need to obey what God instructs us to do. So . . .

A. Stop trying to fix things.

> The Lord of hosts is with us;
> The God of Jacob is our stronghold.
> Come behold the works of the Lord
> Who has wrought desolations in the earth.
> He makes wars to cease to the end of the earth;
> He breaks the bow and cuts the spear in two;
> He burns the chariot with fire.
> Cease striving and know that I am God;
> I will be exalted in the earth.
> The Lord of hosts is with us;
> The God of Jacob is our stronghold. (Psalm 46:7–11)

B. Stop focusing on what you can't fix and turn your attention to God.

> But seek first His kingdom and His righteousness;
> and all these things shall be added to you.
> Therefore do not be anxious for tomorrow;
> For tomorrow will care for itself. Each day has
> enough trouble of its own. (Matthew 6:33–34)

The next time some great storm descends on you, wrap this knowledge around your heart. Whatever it looks like, God is in control. Whatever if feels like, He is near. He is our refuge, our shield, our helper and our deliverer.

Submission to that knowledge will give us peace right in the middle of the storm.

That works. Nothing else really does.

Yesterday

If we look behind us, for most of us, there is a lot back there. Repeatedly, we've been done wrong, and repeatedly, we've done wrong. In both situations, we get stressed and, if these stresses go unresolved, we get stuck in bitterness and guilt. These are heavy weights to bear. But, just like God instructs us not to obsess about tomorrow (Matthew 6:34), He wants us to be freed from our past.

Paul, in stating his life purpose, commented about yesterday in Philippians 3:13. He said " . . . but one thing I do; *forgetting* (*epilanthanomai*: no longer caring for; given over to oblivion) what lies behind. . . . I press on. "

In the next two chapters, we'll look at two more very common causes of stress: the wrongs done to us and the wrongs we've done.

VII

Wrongs Done To Us

"Anger is a killing thing; it kills the man who angers,
for each rage leaves him less than he had been before–
It takes something from him."
Louis L'Amour

There was a constant, gnawing feeling in the pit of her stomach. It was like her stomach was calling for food but the pain never left. Her mouth was burning with a bitter taste. She had tried everything she knew to make it stop but nothing was helping. So she decided to see the doctor.

I had known this woman for many years. She was a responsible, caring, intelligent person who worked for a large corporation. Like all others, this company was trying to improve their bottom line. Getting rid of higher paid senior staff was one way to do this. During the previous year, I had known that they were increasing her work load, decreasing her staff, and repeatedly giving her negative evaluations. Finally the pressure was too great and she resigned. . . . but it seemed so unfair. Her pension was gone. Her health insurance was gone. She hadn't done anything but do her job well. She couldn't get past her

anger. The lack of resolution was eating at her stomach. The unending stress was ruining her body.

She was complaining about her stomach but her heart was the problem. She wanted antacids but what she needed was justice.

There are a lot of angry people, and anger makes people stressed. When anger is not resolved, it becomes bitterness and bitterness makes us sick and hurts innocent people. Knowing God is essential to become completely free from anger.

In this chapter, we'll look at what causes anger, and what causes bitterness.

A. What causes us to get angry?

1. Perception
People stink. This may sound a little harsh it's a Biblical thought.

Humanists tell us that the basic nature of man is good. If we believe this, we'll be continually surprised by what people do. People are fallen beings and they have an evil nature. How evil are they? People are born evil (Psalm 51:5). Their intents and thoughts are continually evil (Genesis 6:5). From deep inside them, come all kinds of bad stuff (Mark 7:21–22), and they remain in this condition throughout their lives (Ecclesiastes 9:3). So, if we live among such beings, bad things are bound to happen.

What do such evil creatures do to each other? They

threaten each other. They hurt each other. They inflict harm with their intentions; with their words; and with their actions. They hurt others physically, financially, and emotionally. People stink. They really stink.

2. Longing of our heart

Ever since we were little kids, we had a sense of the concept of fairness. If all the big kids were on one team, we knew it wasn't fair. If the teacher had a "pet," we knew it wasn't fair. If some kids were more popular than we were that wasn't fair. As we get older and perceive how people treat us and others (Ecclesiastes 3:16), we sense that often life itself isn't fair. Our inner sense of justice is alarmed. Our hearts dry out, "O let the evil of the wicked come to an end, but establish the righteous." (Psalm 7:9) We long for justice. Our hearts need justice but what we see and experience is often unjust. So the sound of our heart's need and the sound of reality clash. We can hear and feel the dissonance. So the stress begins.

B. What causes us to become bitter?

So we perceive and experience all these people doing all kinds of evil things. Our hearts, filled with the need for justice, becomes alarmed by the sense of unfairness, and so we enter the stressed state of anger. Where do we go? Where do we take our thirsty hearts for answers and solutions? Often, people go to the desert—the place where we trust in our own thoughts and ideas or those of other people. We forsake God. In this place, the desert, there is no objective map for dealing with anger. There is no

example. Instead, we have other people's thoughts about what to do. The bush in the desert approach to anger is don't get mad, get even.

1. Don't get mad.
Secular anger management says try to talk ourselves into not being angry. Here are some actual quotes:

a. "Call a truce with anger . . ." i.e. pretend we're not angry.

b. "Rewire your hot buttons."

c. "Tell your story."

Some of this is healing and helpful but fairly superficial (Jeremiah 6:14) because it doesn't deal with our need for justice. Therefore the need for justice is never satisfied. Our thirst is never quenched. Angry people go to the desert and dig their own cisterns looking for some "water" but find that the cisterns leak. We remain thirsty and angry.

2. Get Even
The other approach to anger management is more direct. If we get pushed, then push right back. If people threaten us, we threaten them. If they do evil to us, we do it to them. If someone curses or hates or abuses us, we do it right back. What we need to do is to tip back the scales of justice ourselves. We need to make things right ourselves. The problem, of course, is that we never can really balance the scales. We don't have the capacity or the ability. When we repay evil with

evil, all we get is twice as much evil. So, we remain thirsty. Our anger remains unresolved.

When anger remains unresolved, when it festers, it isn't pretty. We end up with bitterness. The Greek word for bitterness is *pikria* which means bile or gall. It's a word also used for poison (Job 20:14). Unresolved anger becomes a bitter poison that contaminates us and everything we touch. Eventually, it causes our own brokenness.

Bitterness (unresolved anger) contaminates and ruins our:

Minds: our perception becomes distorted and we misinterpret what we see.

Emotions: unresolved anger leads to depression and lack of self-esteem.

Bodies: unresolved anger increases cardiac events and all causes of mortality.

Relationships: innocent people are affected by our bitterness.

Hebrews 12:15 says " . . . by it (bitterness) many are defiled . . ." Spouses, children, parents, and friends are all contaminated by our bitterness. They're subjected to verbal, emotional, and physical abuse.

So we took our anger to the desert and it was never resolved. We never got justice. All we got as more evil, bitterness, and brokenness. When we're angry and don't take God into account, that's what we get.

CONNECTION . . . KNOWLEDGE . . . OBEDIENCE

If we're connected to God, what knowledge will guard our hearts and prevent the hostile invasion of anger? What knowledge will give us peace even in the midst of a world filled with fallen people doing evil and unjust things?

Jesus turned the world upside down. We've been instructed to turn anger management upside down. God tells us "get mad, but don't get even."

It's okay to get mad. Jesus did. Jesus got angry at the money changers for perverting God's plan (John 2:15–16). He got angry at the Pharisees for their hard hearts (Mark 3:1–5). He even got angry at the disciples for their lack of compassion (Mark 10:13–14).

We're instructed to get angry but there is a stipulation. In the New Testament we're told "Be angry and sin not . . ." (Ephesians 4:26). In the Old Testament we're told "Tremble (*ragaz:* shake with anger) but do not sin." (Psalm 4:4) We can get angry but we're not supposed to sin.

So what knowledge does God give us to free us from unresolved anger and spending our lives stuck in bitterness?

Let's pretend we're going for a ride on the "Anger Interstate." This road leads to the village of Bitterness. We'll end up living in that place if we miss the road signs. On that road, there are three signs that ask three questions. There are four off ramps to exit the highway. When we feel anger, we need to be reading those signs and find

those exits or we'll end up in Bitterness. When we get on that path of anger, we need to ask these questions about our anger:

1. Is it appropriate?
2. Can it be ignored?
3. How do we respond?

1. Is it appropriate?

When we're stressed by anger, we're often happy to talk about it. We want to tell others how people have done us wrong. We love to go into great detail, having dissected every action and attitude of the other person. But what do we know? What did God tell us? In Matthew 7:3–5, Jesus paints a rather humorous picture. Imagine someone going to an emergency room with a little speck in their eye. They've gone there to get help. They want a doctor to remove the speck. Now pretend we're the doctor. We're the one who needs to do the delicate work of removing the speck. The only problem is that, stuck in our own eye, we have a log—a great big, fat log. Well, what do we suppose our patient would say as they sit there, horrified, as we approach them with a pair of forceps? Almost certainly they would like us to take the log out of our own eye before we started any speck removal.

So it is with anger. Before we start inspecting and dissecting the problems with other people, we need to look at ourselves first. Is our anger appropriate? Is there anything wrong with our own attitudes or actions? What leads to inappropriate anger?

- **Guilty consciences**

 When we're doing something wrong, the last thing we want is to have people pointing it out. It makes us mad. It made Peter mad in Matthew 26:69–75. When people kept saying he was one of Jesus' followers, he kept denying it which, of course, was wrong. After a while " . . . he began to curse and swear 'I do not know the man.' And immediately a cock crowed. . . ."

 " everyone who does evil hates the light, and does not come to the light, lest his deeds should be exposed." (John 3:20). Maybe we're mad at someone who is exposing some wrong thing in our lives. That's inappropriate anger. We need to stop being mad and, instead, confess and deal with the wrong.

- **Jealousy**

 Maybe we're mad because we're jealous of someone else's success, recognition, popularity, or looks. Maybe we want what that other person has just like the brother of the prodigal son (Luke 15:25–28). When invited to his brother's big party " . . . he became angry and was not willing to go in . . ." He was jealous. Why was his bratty, irresponsible brother getting a big party and he, who was the picture of responsibility, was not getting much of anything? Jealousy makes people mad, but that's inappropriate anger. When we're angry because of jealousy, we have to stop being angry. We must recognize that God is the Master. He gives whatever He chooses to whomever He chooses. That's His right. He's God. We're not. We should

be thankful for what we have; not angry about what we've lost or never had.

- **Self-centeredness**

Probably the most common cause of inappropriate anger is self-centeredness. We want things *our* way. When we don't get it, we get angry. Jonah didn't want God to show mercy to the people of Nineveh. Jonah didn't like them. When God did show them mercy " . . . it greatly displeased Jonah, and he became angry." (Jonah 4:1)

Maybe we didn't get our way in some part of life and we got angry. That's inappropriate anger. We should stop being angry and prefer God's will to our own (Luke 22:42), just like Jesus.

If we know God and what He's said, we'll first look at ourselves when we start feeling angry. Anger isn't always righteous. Sometimes it's from our own sin. So we shouldn't miss this sign. If the anger is inappropriate, then the ride is over. We must take the exit, park our car, confess our sin, and stop being angry.

2. Can it be ignored?

Maybe we've believed the lie that there's no reason to put up with people; that we're entitled to get angry at every little thing.

Knowledge of God helps us here too. Knowing what He's said and who He is can free us. "A man's discretion makes him slow to anger and it is his glory to overlook a transgression," (Proverbs 19:11). We are to be slow to

anger (Ecclesiastes 7:9, James 1:19). We're not supposed to get angry at every little thing.

Why not? Why shouldn't we call people on every transgression they commit? Why should they get what they don't deserve? Why shouldn't they get what they do deserve? Again, we need to wrap some knowledge around our hearts. . . . some knowledge of God. How has God dealt with us?

God has shown us mercy and grace. "He has not dealt with us according to our sins nor rewarded us according to our iniquities," (Psalm 103:10; see also Ezra 9:13 and Lamentations 3:22). Has God given us any good things that we don't deserve? Has He not given us all the bad things we do deserve? Has God shown us any grace? How much grace? Lots of grace. We're debtors to God. We're debtors to grace. We need to drawn on some of that debt in dealing with people.

> "O to grace how great a debtor daily I'm constrained
> to be . . ."

So, here's the second sign and the second exit. Can it be overlooked? Come on, how has God treated us? Be real. Many things can and should be just overlooked. Forget about it. Take the exit. Park the car. Remember the grace of God.

There, however, some things that can't and shouldn't be overlooked. What are they? When can we, even if we've read the sign, stay angry? When is it appropriate to stay angry and not overlook the situation? There are, at least, three of these situations:

1. A situation in which dishonor is brought to God

Imagine someone who claims to be a Christian consistently acting in way that causes others to think poorly of God. That can't be overlooked. "You boast in the Law, through your breaking of the Law, do you dishonor God? For the Name of God is blasphemed among the Gentiles because of you. . . ." (Romans 2:23–24)

2. A situation in which the offender is hurting others

If a situation significantly harms us or others, it can't be overlooked. Sin hurts innocent people. It contaminates everyone it touches. " . . . a little leaven leavens the whole lump?" (Galatians 5:9)

3. A situation in which the offender is being hurt

Sin hurts the people who are committing it. When an offence significantly harms the offender, it can't be overlooked. When people sow a bad seed, they'll reap a bad harvest. "Do not be deceived, God is not mocked; for whatever a man sows, this he will also reap," (Galatians 6:7; see also Job 4:8, Hosea 8:7).

3. How should we then respond?

When our anger is appropriate and the situation is such that it can't be overlooked, there are some general ways we should address the situation:

a. Quickly: As soon as we're sure that it is appropriate to be angry and that we can't overlook it, we need to address it. "Be angry and yet do not sin, do not let the sun go down on your anger," (Ephesians 4:26). Time turns anger into bitterness.

b. Directly: We must speak directly with the offender. "And if your brother sins, go and reprove *him*. . . ."(Matthew 18:15). We don't talk to others about the matter. We talk directly to the offender.

c. Privately: We must not discuss the matter in front of others. We should discuss it with the offender alone. "And if your brother sins, go and reprove him *in private. . . .*"(Matthew 18:15).

d. To correct; not punish: The purpose of the confrontation is not to punish; Christ took care of punishment. The purpose is to win over (*kendaino:* to win over to the Kingdom of God; to gain Christ's favor and fellowship) our brother and sister. "And if your brother sins, go and reprove him in private; and if he listens to you, *you have won (kendaino) your brother*," (Matthew 18:15).

If the person listens and asks for forgiveness, what do we do?

We may be captured by the lie that there are some things that just can't be forgiven or there is really no good reason to forgive people anyway. If we believe this lie, we'll stay angry and end up in bitterness unless we remember God; what He's told us about ourselves; and what He's done for us.

God has told us that we have sinned greatly against Him. "For evils beyond number have surrounded me. My iniquities have overtaken me, so that I am not able to see; they are more numerous than the hairs of my head and

my heart has failed me." (Psalm 40:12) Remember feeling like that about the wrongs we've done? What did God do when we asked for forgiveness? He forgave us. How much has He forgiven us—a lot (Colossians 2:13–14). Who are we to not forgive anyone for anything (Matthew 18:21–35).

If we know God, if we wrap our hearts with the knowledge of how much He's forgiven us, when that person has been confronted and has asked for forgiveness, we'll be free to say its okay. We'll be able to exit our anger.

> If the person won't listen or won't ask for forgiveness, what do we do?

We may be stuck in bitterness because we've believed the lie that we have to get even. We have to get back at the offender. We have to tip back the scales of justice ourselves. But if we know God, we'll know what He said about who He is, and what we're to do.

We don't have to make things even. Here's what God said we shouldn't do: "Never pay back evil for evil to anyone . . . Never take your own revenge . . ." (Romans 12:17,19). Here's what God said we should do: " . . . love your enemies, do good to those who hate you, bless those who curse you, pray for those who mistreat you . . ." (Luke 6:27–28).

And here's how we do it. The same way Jesus did it when He was treated unjustly. " . . . and while being reviled, He did not revile in return; while suffering, He uttered no threats but *kept entrusting Himself to Him who*

judges righteously," (I Peter 2:23). We shouldn't get stuck in anger, trying to get even. Leave it to God.

To keep out of the land of bitterness, we need to wrap all this knowledge around our hearts. People who want to do speck removal can't have logs in their eyes. When angry, we need to check our own hearts first.

God is gracious . . . Don't be so sensitive.

God forgave us lots of stuff. Don't be unforgiving.

God is the righteous judge. He'll take care of justice. We don't have to.

If we know God, we won't get stuck in anger.

VIII

The Wrongs We've Done

"But they who guilt within their bosom lie,
Imagine every eye beholds their blame."
William Shakespeare

All her life, she had done things for other people. She never missed a chance to encourage, help, or show kindness. She was devoted to her family and gave up much to care for her aging mother.

Yet there was always sadness about her.

She had asthma which was a constant problem, frequently experiencing exacerbations. I saw her during one of these episodes. It was a very memorable visit. After years of knowing her, that day she confided in me that, as a young unmarried woman, she had had an abortion. She wasn't a religious person. She had never really thought much about God, but that day she seemed open to spiritual things. She explained how she had felt guilt all her life and nothing she tried had helped. When the thoughts of what she had done would rise up, so would her asthma.

Her wheezing was a symptom. Her heart was where the problem lay. Inhalers would only help the symptom. Forgiveness is what would heal her.

Unlike troubles and anger, guilt results from an internal conflict and is often suffered silently. In this chapter, we'll look at what causes this conflict and how it can be resolved.

We all know there are boundaries in life and it's wrong to cross them.

There are physical boundaries. Signs and fences help us know about these. You can't drive your car on the sidewalk. There are boundaries. You can't chop down a tree in your neighbor's yard. There are boundaries. Touchdowns are not awarded to players who run out of bounds, and foul balls are never home runs. There are physical boundaries.

There are civil boundaries. Reading state, federal, and local laws help us know about these. You can't help yourself to a stack of twenties at the local bank. There are boundaries to behavior. You can't yell "Fire!" in a crowded theater. There are boundaries to speech. Your freedom ends where my nose begins. There are civil boundaries.

There too are absolute boundaries for human behavior. These are universal, eternal, and set by God. There are boundaries for our actions and our reactions. There are boundaries for our thoughts; our speech; our attitudes; and our priorities. Boundaries do exist and we all know it. It's instinctive, it's written in our hearts, and it's in our consciences. Romans 2:14–15 says "For when Gentiles who do not have the Law do instinctively the things of the Law, these, not having the Law are a law to themselves, in that they show the work of the Law *written in their hearts*, their consciences bearing witness and their

thoughts alternately accusing or else defending them." So inside us we know there are boundaries.

The problem is that within us is also a universal tendency to cross those boundaries. We don't understand it. We often don't like it, but we can all sense it. In us is a nature that seems compelled to transgress the boundaries (Romans 7:15–21). So the conflict is born. We know there are boundaries. We know the great draw within us to cross them, and of course, we all do—not one of us hasn't. Each of us has their own favorite boundaries they like to cross and each of us crosses them.

"Every one of them has turned aside; together they have become corrupt, there is no one who does good, not even one." (Psalm 53:3)

"All we like sheep have gone astray." (Isaiah 53:6)

"For all have sinned and fall short of the glory of God." (Romans 3:23)

What's more, when we transgress God's Law, we know it.

"For I know my transgressions, and my sin is ever before me." (Psalm 51:3)

"Our consciences accuse us." (Romans 2:15).

Thus, inside us, in our hearts, we know right and wrong. We keep doing wrong. Just like the apostle Paul (Romans 7), we keep doing the very things we hate. So the conflict begins, and with it the guilt.

The Desert
When we're thirsting for resolution for our transgressions and guilt, we can go to the desert, (Jeremiah 17:5) the place people forsake God and trust other people/them-

selves. The desert is filled with lies. It's a place where a person, weighed down with guilt can go to try and find some relief. In the desert our minds can get captured by lies. Here are the lies the desert will offer us when we're suffering from guilt:

1. We can tell ourselves that there are no boundaries. There are no absolutes, or a more subtle version, the boundaries don't apply to our case. The good outweighs the bad; God would want us to be happy and therefore the boundaries can be stretched.

2. We can play the blame game. There are fixed boundaries but we were dragged over them by someone else. It's their fault.

3. We can say there are boundaries. It is our fault and there has never been a sinner like us. There is no redemption for this transgression. It's too big. Our only hope is to "undo" it. We'll have to work very hard the rest of our lives to make up for what we've done.

Of course, taking our conflicts to the desert never results in resolution because there is appropriate guilt and no one in the desert has the ability to really get rid of it. Instead we get lies and slavery. Enslaved to guilt, we become broken. We become defeated by the guilt. The guilt stains us. It defiles us. It makes us feel dirty. We feel contaminated. Self-esteem turns into self loathing. "O wretched man that I am!" (Romans 7:24). It becomes a heavy burden like a yoke around our neck (Lamentations 1:14). It becomes like a great weight, too heavy to bear (Psalm 38:4). It

accuses us. It tells us that God can't possibly love us and certainly no one else does.

So, finding no resolution for the wrongs we've done, stained and burdened; we become broken.

Living Water

Jeremiah 17:7 says blessed is the man who trusts in the Lord. The person who looks to God for resolution is a joyful person. What is it about that Living Water? What is it that we know about God that can set us free from slavery to guilt? What did God do?

" . . . He loved us and sent His Son. . . ." (I John 4:10)

> "And when you were dead in your transgressions and the uncircumcision of your flesh, He made you alive together with Him, *having forgiven us all* our transgressions, having *cancelled out* the certificate of debt consisting of the decrees against us and which were hostile to us: and He has *taken it out of the way*, having *nailed* it to the cross." (Colossians 2:13–14)

According to Christian teaching, the above verses describe what God has done with our transgressions. He forgave them all. He cancelled them. He took them out of the way and He nailed them to the cross.

1. ". .having forgiven us all our transgressions. . . ."

Here we have two thoughts for those who have believed lie number three. First, He has forgiven *all* our transgressions. There is no transgression that is greater than God's forgiveness. Nothing we've done, no matter how

grotesque the act, is beyond God's ability to forgive. God has the authority to forgive. No one else does. What's more, the word here for forgiveness (*charizomai*) means "to grant forgiveness freely." God forgives at no cost to us. There's nothing we have to do. There's nothing we have to undo. It's free.

> "Let the wicked forsake his way, And the evil man his thoughts; And let him return to the Lord, And He will have mercy on him; And to our God, For *He will freely pardon.*" (Isaiah 55:7 NIV)

> "...being justified *freely* by His grace, through the redemption which is in Christ Jesus." (Romans 3:24 NIV)

> "And the Spirit and the bride say, 'Come.' And the one who hears say, 'Come.' And let the one who is thirsty come; let the one who wishes take the water of life *without cost.*" (Revelation 22:17; see also Revelation 21:6)

2. "... having cancelled out ..."

God can cancel out the wrong we've done. The word *exaleipho* means to blot out, to erase, to wipe away. The stain, contamination, the spot on our soul is wiped away. It's gone. God can give people second chances.

"I, even I, am the one who wipes out your transgression for My own sake; And I will not remember your sins." (Isaiah 43:25)

"And I will cleanse them from all their iniquity by which they have sinned against Me..." (Jeremiah 33:8)

3. " . . . He has taken it out of the way. . . ."

Airo means to elevate: lift; to bear away; to carry off what has been raised up." God takes the burden off. That oppressive weight of guilt is lifted.

" . . .and He Himself bore our sins in his Body . . ." (I Peter 2:24)

"Surely He hath bourn our grief and carried our sorrows." (Isaiah 53:4 KJV)

4. " . . . having nailed it to the cross. . . ."

Where were our burdens lifted and our transgressions cleansed? It was at Calvary—the cross. The burden of all our transgressions was raised up and taken away at the cross. The stain of our transgressions was washed away by Jesus' blood.

> "Knowing that you were not redeemed with perishable things like silver or gold from your futile way of life inherited from you forefathers, but with precious blood, as a lamb unblemished and spotless, the blood of Christ." (I Peter 1:18–19)

So what does all this tell us? God sent His Son to die for me. I must be loved by God. I must be of great value. There we have it. In the desert we get lies; oppression; a stained and burdened heart and self-loathing. With God, we get all encompassing grace; forgiveness; relief; and love. What should we do with our guilt? Where should we take it? You choose.

Today

We've seen that the storms of life can get us stuck in worry and obsessed about the future. The wrongs done to us and the wrongs we've done can result in obsession with the past. There's no freedom in the desert. Freedom from the past and future only comes from connection with; knowledge of; and submission to God. Sometimes we idealize the past and the future. We dream about a time when things will be better, or we dwell on a time when things were better. In the process, we forget about today. We often consider today as something of little value. Today is far from that. It is not a purposeless, random, chaotic mess. It is not some inferior imitation of yesterday's glory or some impediment that requires enduring on the way to some brighter tomorrow. Today is not an inferior obstacle. What is it?

1. Today is an excellent day.
Today was fashioned by God. "This is the day which the Lord has made (*asah:* to fashion) (Psalm 118:24). God made today. He fashioned it just like He fashioned the firmament (Genesis 1:7); the sun and the moon (Genesis 1:16); the beasts of the earth (Genesis 1:25); and man (Genesis 1:26). And whatever God makes is very good (Genesis 1:31). In fact, it's wonderful (Psalm 139:14) and excellent (Psalm 8:1, 3). Today is excellent because God made it.

2. Today is great value.

Often we see advertised what are called "limited series editions." Often they are numbered to give us the idea that there aren't many (so we'd better hurry and buy one). They are rare and, so, they are valuable.

Our todays are a limited series edition. They are numbered (Psalm 90:12), there are just a few of them (Psalm 39:5), and they go by quickly (Psalm 39:5b; Job 7:6; 9:25; James 4:14). Todays are limited series edition. They are very valuable.

3. Today is very important.

Someday, there will be a replay of every today. We will have to give a report to God on what we did with each of them. Todays are very important.

4. Today is filled with opportunities and duties.

 a. Today is the only day we can change something about ourselves (Hebrews 3:7–8).

 b. Today is the only day we can have an impact on our world (Colossians 4:5).

Therefore, today—this very day—is an excellent, valuable, important day filled with opportunities. Don't waste today. Do something good with today.

In the next five chapters, we'll look at five different ways our today can get attacked.

IX

What We Are

"A man cannot be complete without his own approval."
Mark Twain

He was a man in his sixties, very stable, very bright, and well accomplished, but he suffered from recurring bouts of depression. His life would often be put on hold while he worked through these episodes.

When I would see him suffering with early morning awakening, loss of motivation, a desire for isolation, inability to concentrate, feelings of helplessness and even hopelessness, I would do what most doctors would do. I gave him medication and sent him to counselors and psychiatrists. They helped, but only slightly. Counseling would help him understand and alter his behavior, and the medicine he was given would increase his depleted neurotransmitters. His symptoms were being treated, but not his disease. After years of observing and trying to help him with his problem, he expressed something that had been in his heart for years. As a child, his mother would constantly belittle him, telling him he was ugly and stupid. She would scream at him and tell him she had no idea

why he was born. She would say she was sure he would never amount to anything ever in his life.

All these years his heart was thirsting. Deep inside him, he longed for a sense of worth. No relationship, no accomplishment, no praise of men could quench his thirst. The stress never resolved. He was broken by depression and enslaved by self-loathing.

We can waste today if we feel we're of little use and little value. Self-esteem is a basic human need. Our hearts thirst for a real sense of our own worth and value. In the face of this basic need, come multiple voices that tell us we're not really worth much at all. Our own mind whispers to us that we're not really as good as others. We're not as smart, as rich, as attractive, or as successful. Other people (especially those who don't feel that good about themselves) are happy to remind us all the things that are wrong about us. Often it seems as if the whole world is singing the words to the old Clint Ballard, Jr.'s, song, "You're no good, you're no good, you're no good . . . baby. You're no good." And so the stress begins, the dissonant sounds of hearts' need for worth, and a world telling us the contrary. Where do we take our conflict for resolution?

The Desert

In our thirst for self-esteem, we can forsake God and go to man looking for answers. There, in the desert, we're told that the answer comes from within ourselves. All we need to do is to tell ourselves convincingly how very good we

are. We must affirm ourselves. We must be positive. Then we will be confident and able to overcome any obstacle or opposition. That's the ticket. Be positive and confident.

The only problem with this approach is that it's not true, therefore, doesn't work. Each of us knows that we're really not that good. We know all the things we've done wrong. We know all the times we've transgressed. We know our own sins better than anyone. Just like David (Psalm 51:3), our most grotesque sins are ever before us.

What's more, we know we can't be that confident. There are obstacles bigger than we are and opponents stronger than we are. There are some things we just can't do. With people, certain things are just impossible (Matthew 19:26).

This doesn't seem to work. We can try to talk ourselves into believing what isn't true, but eventually we'll figure it out. In the desert, all alone, looking at ourselves, it's not that pretty a picture.

When people don't feel a real sense of worth, they refuse to attempt challenges (e.g. Gideon in Judges 6:14–16, Moses in Exodus 4:10, Jeremiah in Jeremiah 1:6) They then feel worse about themselves and get mired in self-loathing. People who consistently don't feel good about themselves eventually experience brokenness.

Living Water

Apart from God, Clint Ballard, Jr., might be right but if we see ourselves in relationship with God and know God, then we can see we are of great value. If we guard our hearts with specific knowledge of God, those hostile

voices won't be able to invade us. If we've been wandering around the desert, looking desperately for a sense of some worth . . . what do we need to know?

1. God loves us.

God loved us enough to send His Son—His only Son— the Son who He loved, to die for each of us (I John 4:10). If this is true, it's an incomprehensible reality. If this is true, we must be worth a lot. God loved us enough to adopt us as His own children (I John 3:1). God is, then, our Father. We are His children. We are children of the King. We must be worth a lot.

2. God created us.

What God makes is good (I Timothy 4:4). We've been created, shaped, and formed by God. We are of great value.

3. In Christ

a. We have purpose.

Things that are created are usually created for a purpose. We've been created and we have a purpose (Ephesians 2:10). We were created to do "good works," things that count for eternity. That's petty good. We must be worth something.

b. We have ability.

We have the ability and power do those good things that count for eternity (Ephesians 3:20), not because of any greatness in us, but because we're connected to God (II Corinthians 3:5). Therefore " . . . God is able to make all grace abound to you, that always having all

sufficiency in everything, you may have abundance *for every good work*," (II Corinthians 9:8).

Separated from God, it's difficult to see any reasonable purpose for today and for our lives. Connected to God, we have worth and purpose. Every today, we have something we're supposed to do: good works. Connected to God, we have confidence that we can do them because He is our sufficiency. In the desert, we can get mired in the pain of self-loathing. Connected to the Living Water, the Truth makes us free.

X

The Unending Demands of Life

*"There cannot be a crisis next week.
My schedule is already full."*
Henry Kissinger

"**M**y heart is skipping and racing a lot and it kind of scares me." This was, as we say in the profession, the chief complaint. The attractive, 40ish, black executive had been experiencing this erratic heart beating for months. She was a mid-management, driven woman with four fairly young children and a good marriage. All the kids were involved in multiple activities. She desperately wanted to maintain her quality marriage while pleasing her children, her bosses and her staff.

Unlike the others we've looked at, she did know the skipping of her heart was just a result of a deeper process. Inside her, she lacked the means by which she could unify all these disparate parts of her life. She could find no such devise. So she continued trying to please everyone.

I see a lot of people who are in the same condition as Martha in Luke 10:38–42. The text says she was "troubled

with care; bothered (her mind was disquieted); and distracted (drawn about mentally)." This is our culture. People's minds are going in multiple directions (multi-tasking) and as a result, they are anxious and lacking any sense of peace. What was Martha's problem? What caused her condition? The text says all of this was caused by "many" (*polus*: many, much, large numbers of) "preparations" (*diakonia*: serving). In other words, Martha didn't get into this condition by doing too many bad things, but by too many good things—too much serving. She was just doing too much. She was being pulled in too many directions.

People get stressed when they try to do too much, but of course there's a lot to do. There are many things that we have to do: jobs; houses and cars to attend to; kids and their needs; parents and their needs; perhaps church responsibilities. There are many things we should do: house projects; people to visit; people to call; letters to write. And, of course, there are many things we may want to do: hobbies; books to read; places to see. Conflict arises from the fact that we are finite creatures. We have limits. We have limited time. We have limited energy. When seemingly endless demands meet a finite person, where can they go for answers?

Desert

> But the wicked are like the tossing sea,
> For it cannot be quiet, And its waters toss up refuse
> and mud. "There is no peace," says my God, "for the
> wicked." (Isaiah 57:20–21)

This is a good picture of people facing the demands of life, apart from God. Life feels like a tossing sea. It's never quiet. There are eddies, little sidetracks. There are whirlpools; we seem to go in circles and never get anywhere. There are counter–currents. We want to do many things but they conflict with each other. If we do one thing, we can't do another. All this chaos stirs up bad stuff. We become exhausted, irritable, and angry. All the "refuse and mud" soils other people around us. In the desert, apart from taking God into account, the competing goals of our lives produce unrest, irritability, and exhaustion. In the desert, there's no effective means of sorting this out. There is no overriding purpose. There's no effective way to quiet the tossing sea. There's no unifying principle.

Living Water

> "If only you had paid attention
> to My commandments! Then your peace would
> have been like a river." (Isaiah 48:18)

Or we could turn to God for answers when life seems overwhelming. There are so many forces pulling at us, often in many different directions: careers, family, health needs, friends, relatives, possessions, chores and desires. As we've seen, they often seem to clash and crash against each other just like the waves of the ocean, and there never seems to be time enough to do them all. How then can we get all the parts of our lives to turn into one direction? Where can we get perspective to help us know what's important;

what we should do; and what we don't have to do? Only a transcendent goal can pull everything in one direction. Only some great, majestic focus can dwarf varied urgencies of life. Apart from God, there is no such goal or focus. No earthly life goal can do this. None is great enough. None is worthy enough. Only God is worthy. Only God can pull every part of life in the same direction and give us perspective.

God is worthy to be the focus and goal of our lives because of His greatness.

> Worthy art Thou, our Lord and our God, To receive glory and honor and power. For Thou didst create all things, And because of Thy will they existed, and were created. (Revelation 4:11)

A sunrise, a sunset, the mountains, the ocean, the earth, the universe; it's beyond reason to suppose all this to be some gigantic accident rather than the work of an incomprehensible intelligence. From DNA to the function of the body to the expanse of the universe—there is reflected an order, beauty, and excellence that is worthy of our full devotion. The heavens do indeed declare the glory of God and such glory is worthy to be the focus of our lives.

God is worthy to be the focus of our lives because of His goodness.

> Worthy is the Lamb that was slain To receive power and riches And wisdom and might and honor And glory and blessing. (Revelation 5:12)

How could it be that such a great and majestic God would be mindful of us? How could it be that such a great and

majestic God could send His only Son to become a man to endure such hostility from sinful men? How could God be willing to sacrifice His Son for someone like me? How incomprehensible is that love? How excellent is that love? How worthy is such love?

The existence of a God so great and so good would make trivial and meaningless all of other life pursuits. When we understand the glory of God, everything else, the things of the earth, do grow strangely dim. We'll get perspective. We'll know what's important and what's not. We'll seek first the things of God and everything else will follow.

And we'll have peace—peace like a river. If such a good and great God exists, then every part of our lives should be about making Him known, reflecting His excellence through our own lives. That's what glorifying God is. So then, all the parts of our lives: career; family; leisure; and possessions will have the same purpose. All the parts will flow in the same direction. Life will no longer be like a raging ocean but more like a peaceful river . . . flowing in one direction. No more eddies. No more whirlpools. No more countercurrents. The desire to display God's love and God's truth will be the mainspring of our lives. It will touch every part of our lives. It will give focus, perspective and peace.

This only comes from relationship with God. You can't find this in the desert.

XI

A Cold World

"To be an adult is to be alone."
Jean Rostand

How often I've seen her come in the office, the widow in her seventh or eighth decade. Her hair freshly set, dressed up for the occasion and always carrying "the list." But this list isn't just a list of physical complaints. It's simply a way to prolong her visit. It's a means by which she can have a longer conservation. "The list" is a cry of her heart, for just a few minutes, not to be alone.

Her entire visit is a symptom—a symptom of a heart desperate for love.

Everyone agrees on this. People need love. It is a basic need of our souls. Books are written about this. Countless songs, poems, movies, plays have focused on the theme of love. Everyone at every stage of life needs this. People need love. The world, however, can be a lonely place and seems to be getting lonelier. There seems to be more isolation, more indifference, more coldness—so begins the stressed state. We need love but it can be a very lonely world.

So what's the big deal? Why do people need love? Why do people need people? Ecclesiastes 4:9–12 tells us why it's not good to be alone in this world:

> Two are better than one for they have a good return for their labor. For if either of them falls, the one will lift up his companion. But woe to the one who falls when there is not another To lift him up. Furthermore, if two lie down together they keep warm, but how can one be warm alone? And if one can overpower him who is alone, two can resist him. A cord of three strands is not quickly torn apart.

1. Verse 10: In this world we can fall. We can fail in many parts of life. Sometimes we trip and fall (our fault). Sometimes we stumble and fall (something's fault). Sometimes we get pushed and fall (someone else's fault). Failing hurts and it makes us feel weak. When we fall, we often need someone else to help us back up, to encourage us and give us the strength we need to get back up on our feet.

2. Verse 11: In this world we often feel cold. We often feel untouched. We feel the chilling breeze of indifference. We need intimacy and comfort. We need someone with whom to share our deepest feelings. Hurts, fears, wants, failures, successes cry out for the warmth of companionship.

3. Verse 12: In this world we face adversaries; those who oppose us; those who resist our efforts and try to thwart us. Some of these adversaries are very powerful. Often they're stronger than we are. We need others to give us strength.

People need encouragement, intimacy, and aid. People need people. People need love.

The Desert

When people are lonely, they often look to the world or within themselves for answers . . . answers to questions like: What is love? Where do we find it?

What is Love?

The world seems to give love many different definitions: from being a "many splendor thing" to "a warm puppy" to the feeling described as when "the stars hit your eyes like a big pizza pie." Generally, the world tells us that love is a very nice, warm feeling.

Where is Love?

Where can we find this feeling? The world tells us to find the right person and we'll find love. Or maybe find the right cause, or maybe the right job, or how about the right pet. That nice warm feeling is somewhere out there in the world waiting for us to find it. That all sounds nice but what's the reality?

1. Love in the world is limited and flawed. It's flawed by others and it's flawed by us. Sometimes we're not that lovely and sometimes others aren't either.

2. Love in the world is limited and flawed by time. People "fall out of love" because time can cause that feeling to fad. Even if time doesn't fade the feeling, time can separate us from our love through death. Love in this world is limited by time.

3. Love in this world is limited and flawed by circumstance. Poverty, sickness, loss of physical beauty can cause this kind of love to collapse.

What's the Result?

Those who rely on this world for love are often left alone, feeling discouraged, isolated, and afraid in a world filled with our own potential failures, the indifference of others and opposition.

Living Water

Or. . . . we can turn to God when we need love.

What is Love?

Are there any better definitions for love than puppies and pizza pies? Is there any way to know love? 1 John 4:9–10 says, "By this the love of God was manifested in us, that God has sent His only begotten Son into the world so that we might live through Him. In this is love, not that we loved God but that He loved us and sent His Son. . . ." It was quite annoying to hear people criticize the movie, *The Passion of Christ*, because it was all about His death and suffering instead of emphasizing love. What the critics seemed to miss is that this was love, the actual definition of love. Christ became a man and suffered and died for us despite that fact that "we were yet sinners." And He died for us even though we despised and rejected Him.

Love isn't a feeling. It's a commitment . . . a commitment to someone else despite their circumstance and regardless of their response. That's real love. That's *agape* love. That kind of love only comes from God.

Where is Love?

If we're really alone and lonely, where can we go to find real love? Love starts with God and if we comprehend God's love, all kinds of good things will happen. In Ephesians 3:16–20, Paul prayed that his fellow believers would be able to comprehend what God's love is like:

Its breath: God's love applies to all people. No one is disqualified. We can't be too tall, too short, too unattractive, too uneducated, too unsuccessful, too much of a sinner; "Whosoever will, may come . . ." His kind of love is unaffected by the nature or condition of people. The breath of this love includes everyone . . . even us.

Its length: this kind of love is unaffected by time. 1 Corinthians 13:8 says, "Love never fails . . ." The Greek word for "fails," is *pipto*. One definition of *pipto* is to fade like a flower with its pedals falling off. This kind of love, never *pipto*. It never fades with time. This kind of love is forever.

Its depth: this kind of love is not affected by circumstance. The other definition of *pipto* is *to* collapse from external pressure. This kind of love is unconditional. Nothing can separate us from the love of God which is in Christ Jesus (Romans 8:38–39).

Its height: how far did Christ have to come to demonstrate His love for us? The King of glory became a poor baby boy. The Lord of Lords became the Lamb of God. "For you know the grace of our Lord Jesus Christ, that though He was rich, yet for your sake He became poor, that you through His poverty might become rich." (2 Cor 8:9).

What's the Result?

"How can I repay the Lord for all His goodness to me?" (Psalm 116:12 NIV)

1. We'll experience love.

 If we really comprehend the breadth, length, depth and height of the love of God—we will love. We will love God and we love other people. They may or may not love us, but we will experience love, because we will love them. It all starts with God.

 "Beloved, let us love one another, *for love is from God*; and Everyone who loves is born of God and knows God." (I John 4:7)
 "We love, *because He first loved us. . . .*" (I John 4:19)

2. We'll be strong and courageous.

 Knowing God's love gives us roots and ground us (Ephesians 3:17). It strengthens us in the inner man (Ephesians 3:16). It helps us to stand firm against the "the schemes of the devil" (Ephesians 6:11), and enables us to "resist in the evil day" (Ephesians 6:13), and it gives us courage to do great and glorious things. We'll not be afraid of the battle—the spiritual battle. Like King David (I Samuel 17:22), we'll "run to he battle line."

 When we experience the fullness of the love of God, we'll run to our inner battles. We won't be afraid to confront our own demons—our own shortcomings. Love will compel us to want to do things God's way. When we comprehend the fullness of God's love, we'll run to the spiritual battles

in the lives of those around us. We'll want to help. We'll be compelled to help.

Love is like that. It compels us. It holds us on one side and holds us on the other. It paints us into a corner. We'll have no choice. Our will be His. We'll be compelled to love and to be His ambassadors to other people.

Desert love is a flawed feeling that ultimately results in failure and fear.

Agape love is a commitment, learned from God that originates with God. It's unaffected by circumstance or response. The result is a life filled with love (love for God and love for other people) and a life filled with strength and courage to fight the good fight.

"Have I not commanded you? Be strong and courageous! Do not tremble or be dismayed, for the Lord your God Is with you wherever you go." (Joshua 1:9)

XII

Decisions

*"Nothing is more difficult and therefore more precious
than to be able to decide."*
Napoleon Bonaparte

The young police officer came complaining of fatigue. He didn't look like he should be tired. He was a young, healthy appearing man who looked in much better condition than the average person. When the review of systems (questions about all the major organ systems) was unremarkable, I then turned to his life situation. Was anything new, I asked? There was that divorce. He had left his wife of fifteen years for a younger woman. It seemed like a good idea. She was loving and affectionate and attentive to all his needs. His wife, on the other hand, had become distracted with running a household and caring for their two children.

So he had left his wife and moved in with his girlfriend. But now his two sons, who he loved very much, would speak to him only in one word responses if at all. His wife was suing for divorce and his girlfriend was beginning to not look that great up close and personal.

The young officer was stressed, first by his decision and then by the results of his decision.

Caught in chaos and broken in body and emotions, his heart was longing for some way to put things back together again, some wisdom by which he could sort things out, some knowledge that would put order back in his life. He was thirsting for Truth but he didn't even know where to start.

Whether or not we're aware of it, life is constantly throwing tests at us. A test is a stimulus designed to elicit a response. Everyday we face situations that require some response and we need to decide which response to make. How should we act? How should we react? What should our attitude be? What should we think about? Which goal should we pursue? Which path should we take?

Often the situation isn't clear. The decision is difficult. The choices aren't easy. People get stressed not only from the decision making process but also from the outcomes that result from poor choices.

Whether or not we believe it, there is a spiritual world, a spiritual reality. Things are happening in this realm about which we often have little awareness. According to Christian belief, there are two different and opposing forces in this realm which have very different agendas. Both sides use tests.

Temptation
There are powers and forces of darkness in the world. If we look around at our world, this isn't hard to believe.

According to Christian teaching, these forces are interested in people. Their agenda is to separate people from relationship and fellowship with God. They'd like us to be unapproved by God. So they use tests (Greek word: *peirasmos*) to tempt us (1 Corinthians 7:5). They use these stimuli to elicit from us godless responses.

James 1:13–15 describes their strategy. The first step is *exelko*. This is a Greek hunting or fishing term which means to be lured from a hiding place, from the safety of self-restraint. Here the stimulus is used as bait to lure us from our hiding place which is God (Psalm 32:7; 119:114). The bait might be sex, drugs, alcohol, money, power, praise, control, or our own ideas.

The bait triggers step two which is enticement. The bait is often attractive. It looks good. It sounds good. It feels good. It triggers our own desire for what is forbidden (Greek word is *epithumia*: lust). Inside of us there is a force that desires illicit sex; that is pulling us to greed; that draws us to pride and the bait, the test, has lured us from God and triggers in us these primordial urges.

The next step is our choice. The next step requires that we take a bite of the bait. This is our decision. If we bite, we then feel the sting of the hook. We then know we are be pulled around by our own bad choice and pulled away from God.

So every day, according to Christian teaching, big, fat, juicy worms are dangled in front of us. They often are very attractive. They trigger desire in us. So every day we have to make decisions. We have to decide whether or not to bite.

Trials

There is another power at work in the world. It is the power of God. God has a different agenda but He too uses tests (*peirasmos*). His purpose is to test how genuine our faith is . . . to see if, despite the stimulus, we keep His commands.

His purpose is also to refine us. The refining process is very interesting. To make a precious metal precious requires a process. It requires that the raw material be smashed, crushed, and heated up to great temperatures. The process is repeated again and again. The purpose of the process is to remove impurities. In the same way, God uses tests as a "furnace of affliction" (Isaiah 48:10); as a process to clean us of our impurities. In these tests, we also have to make decisions.

Since God never changes. His ways don't change. What He did in Biblical times, He does today. What He did in the lives of Biblical characters, He may be doing in our lives today. So how does God test us?

1. God tries us with extremely difficult commands.
 In Genesis 22:1–2, God gave Abraham an extremely difficult command. God commanded Abraham to sacrifice his son, his only son, the son whom he loved. God was testing him. God has given us commands and situations that can make obedience very difficult. God is testing us. We have to decide whether to obey or do it our own way.

2. God tries us with persistent, oppressive situations.
 In Deuteronomy 8:2, God led the people of Israel in

the wilderness for forty years, forty years of wandering without any apparent purpose, suffering under very difficult circumstances. God was testing them. God allows persistent, difficult circumstances in our lives, situations that seem purposeless and endless. He is testing us to see what is in our hearts. We have to make decisions. We have to decide whether to persevere or to do things our own way.

3. God tries us with overwhelming needs.

In John 6:5–6, Jesus tested Philip by asking him where they could get the food needed to feed a crowd of thousands. This was a seemingly impossible need to meet. This was a test. This was a stimulus designed to elicit a response from Philip. God does the same thing today; He tests us with needs. He uses needs that are seemingly impossible to meet to elicit a response from us. We have to make a decision. We have to decide whether to trust Him or do it our own way.

The Heart Longs for Truth

With all these tests and temptations and trials, we can see why man has always longed for Truth. The human race has been on a constant quest for Truth. We need reliable information about the way things are and the way things ought to be. We need a body of knowledge from which we can draw information that can help us when we're faced with all these decisions. The question is where will we get such information? Where do we look to find Truth?

The Desert

When faced with all these decisions, we can forget about God and turn to people for information. We can get our knowledge from the world. We can stand on the truth that the world offers. There are, however, certain characteristics that are evident about the knowledge offered by people. This kind of knowledge and information is:

1. Limited

 There are some things about which people just don't have any knowledge (Job 8:9). We don't know about tomorrow (Ecclesiastes 8:7). We don't know the way the wind will blow or really how a baby is formed in the mother's womb (Ecclesiastes 11:5). There are a lot of things people don't know anything about. Man's knowledge is limited.

2. Flawed

 Teddy Roosevelt said "There is no human effort without short coming" and that's because our ways are imperfect and our knowledge is imperfect. This kind of knowledge really can't be trusted (Jeremiah 17:5) because it's often wrong. How many people took Vioxx? Very bright people invent medications. They are the brightest of the bright. They acquire information, and they publish their knowledge but their knowledge is often flawed. Sometimes it's flawed because of honest error. People make mistakes. Sometimes the knowledge is flawed because of intentional lies. People lie. In either case, the knowledge isn't good knowledge. Man's knowledge is flawed.

3. Subjective
 Truth is objective. Much of man's knowledge is subjective. This kind of knowledge claims to be reliable, but it is often opinions and speculation tainted by personal motives, agendas, and pride. "A fool finds no pleasure in understanding but delights in airing his own opinions." (Proverbs 18:2 NIV). And, therefore, "He who trusts in himself is a fool." (Proverbs 28:26 NIV)

4. Changing
 Consequently this kind of knowledge keeps changing. If we read a science book from fifty years ago, it's clear that this is true. Man's knowledge shifts. It's like sand. One day one thing is true, and the next day it's not. Decisions based on this kind of information are bound to have bad outcomes. When the worm is big and juicy enough, or life is heating up intensely enough, we need better information than this. When the storms of temptation and trials are severe enough, lives built on this kind of information will go crash.

 And everyone who hears these word of Mine,
 And does not act upon them, will be like a foolish
 Man, who built his house upon the sand.
 And the rain descended, and the floods came,
 And the winds blew and burst against that house;
 And it fell, and great was its fall. (Matthew 7:26–27)

Living Water

When our hearts are thirsting for Truth, when we long for reliable information upon which we can make decisions in the midst of temptations and trials, we could turn to God for our information and knowledge. This kind of knowledge is different. God's knowledge is very much unlike man's knowledge. His knowledge is:

1. Infinite

 God's knows about everything. There's no topic about which He has no knowledge. There's no situation about which he is uninformed (Psalm 147:5).

2. Perfect

 God's knowledge is in no way flawed. It's perfect and therefore it's sure (Psalm 19:7).

3. Objective

 Profound and hidden things are not known to us by opinion, but by revelation. All Truth comes from God and is revealed to us by God (Daniel 2:22). Truth doesn't come from people (subjective) but rather is revealed to us by God (objective). Where do we find this kind of knowledge? Where do go for reliable information about the way things are and the way things ought to be? We find Truth by looking to the written Words of God (John 17:15–17), by looking to the Living Word of God (John 1:14), and through the teaching of the Spirit of God (1 Corinthians 2:12–13). If we want to make right decisions, look at His Word and His Son. Don't trust yourself.

4. Unchanging

This kind of knowledge never changes (Psalm 119:89; Matthew 24:35; 1 Peter 1:25). Almost everything changes, but not the Word of God (Isaiah 40:8). It stands firm. It stands forever. It's a good foundation upon which to make decisions. It's sure. It's better than sand.

Therefore everyone who hears these words of Mine,
And acts upon them, may be compared to a wise man, Who built his house upon a rock.
And the rain descended, and the floods came,
And the winds blew and burst against that house;
And yet it did not fall, for it had been founded
Upon the rock. (Matthew 7:24–25)

Many decisions aren't easy. Often we need some counsel and advice to know what to do. When all those decisions come flying at us, where are we getting our counsel? Are we getting it from the same kinds of minds that brought us Vioxx? Or are we getting them from the mind of God? Which road have we taken? Which way do we go? Is it the way that secular minds have advised . . . the same kinds of minds that ran Enron or is it the way God advised, the Mind that created the universe? Which way do you think will work better? Which way is best? Which way do you really think will bring blessings?

How blessed is the man who does not walk in the counsel of the wicked, Nor stand in the path of sinners, not sit in the seat of the scoffers! But his delight is in the law of the Lord, and in His law he meditates day and night. And he will be like a tree firmly planted

by streams of water, Which yields its fruit in its season,
And its leaf does not wither; And in whatever he does,
He prospers. (Psalm 1:1–3)

XIII

Futility

"How weary, stale, flat, and unprofitable
Seem to me all the uses of the world!
Fie on't, ah fie! "Tis an unweeded garden
That grows to seed, things rank and gross in nature
Possess it merely."
William Shakespeare
(Hamlet Act 1 Scene 2)

His jaw hurt every time he chewed. There was a burning pain radiating to his temple. I asked if his wife had noticed anything unusual while he slept, and of course, she was beginning to complain about the grinding sound of his teeth.

He owned his own business. He had a very successful marriage. His kids were all "good kids." He had no financial or physical worries. Yet the grinding of his teeth betrayed a significant, unresolved state of stress.

The words came out without any prompting. He had done it all. He had accomplished it all and, in his own words, "So what?" He was surprised to hear that Solomon had come to the same conclusion in the book of Ecclesiastes. He was also surprised when I didn't spend much

time talking about his jaw. His jaw wasn't the problem. His heart was. He really didn't need an oral surgeon. He needed a purpose for his life.

Over these decades of practice, I've often seen this final, often devastating cause of stress—the sense of meaninglessness. Often this is seen in people who have everything else pretty together. These are people successful in business, family, and material wealth. They've often gained what they were told would bring fulfillment. While they've seemed to have resolved the lesser issues of life, this issue—the longing for purpose and meaning—remains unfulfilled, and unlike the other stresses of life that are perceived as some great storm, this stress feels more like a constant steady rain. This is not a dramatic event but rather an enduring sense of emptiness.

The human heart longs for purpose and over and over again I've seen that, despite success in the endeavors of this world, people are left thirsting for meaning.

Finding Purpose in the Desert ("Chasing the Wind")

There are things in the world that people eagerly seek (In Matthew 6:32 the word used is *epizeteo*: to seek diligently; to crave; to demand). People chase after things because they believe these things will satisfy them, will give meaning to life and quench this need of their soul. These are the kinds of answers that Jesus spoke of when He said to the woman of Samaria (John 4:7) "Everyone who drinks of this water shall thirst again." This stuff quenches thirst but only for a little while. These kinds of answers give no continuing satisfaction.

The book of Ecclesiastes addresses this same issue of the lack of meaning "under the sun." We see this happening all the time. People are still trying to find purpose and meaning apart from God. People look for meaning in:

1. The attainment of possessions and pleasure (2:4–11)

2. The attainment of wisdom (2:12–17)

3. Success in work (2:18–23)

But in all these things, there is no enduring satisfaction (5:10–11, 15; 2:16–17; 2:21). None of them satisfy. None of them quench the thirst of the soul for meaning. So, though we try and we try and we try and we try—sing along with the Rolling Stones—we can't get no satisfaction. And, in quiet pain, we can hear Peggy Lee singing "Is that all there is?" Is there nothing more to life? Is there no meaning, no purpose, and no water to quench this thirst?

Living Water

Jesus told the Samaritan woman that there was another kind of water. It was "living water" (John 4:10). If a person drinks of this water, they'll never thirst again (John 4:14). Jesus spoke of the Holy Spirit (John 7:38–39). His Spirit would be like a well spring living inside us. His Spirit in us would be a constant supply of Living Water that would constantly quench our thirst. This would give life purpose, meaning and satisfaction. His Spirit would give us purpose through a process for which He would give us provision which we undertake with passion.

1. Process

"For we are His workmanship created (*ktizo:* form; shape; completely change or transform) in Christ Jesus for *good works* which God prepared beforehand, that we should walk in them." (Ephesians 2:10)

For people connected to God, there is an ongoing process. It is a process in which God, the ultimate Designer and Creator, is shaping people into what they were meant to be. Like a potter using pressure to form the clay, God often uses the many pressures we've studied to mold us into what He wants us to become. He can use anything to shape us, even the things we don't like. He can use all the flaming arrows we've seen in the preceding chapters to shape us into His design for us. The worst trial, the worst sorrow, the worst mistake—in God's Hands can be used to "conform us to the image of His Son" (Romans 8:28–29). Connected to God, we can assign meaning and purpose to even the worst of situations, understanding that God is at work in a process. Connected to God, we can know we are being prepared for "good works."

2. Provision

So, for those with relationship with God, we know there is some good (*agathos:* useful; beneficial; pleasant; agreeable; joyful; excellent; distinguished; honorable; right) work (*ergon:* act; deed; thing done; undertaking; anything accomplished by hand; act; industry of mind) that we were created to do. It might be a good work in the area of:

- Sanctification
(becoming more like the nature of God)
 Ridding ourselves of some godless tendencies
 or activities
 Forgiving someone who has wronged us
 Loving some very unlovely person
 Loving a very real enemy
- Service
 Serving a person in some great need
 Serving in a position at a church
- Salvation
 Inviting someone to a church meeting
 Saying the words of life that may heal some
 broken person or free some enslaved person

These are big works. They are large undertakings. They're bigger than we are. They're big like Goliath was big. We don't have what it takes to accomplish them, but remember what David said in 1 Samuel 17:47 when he faced a big task: " . . . and that all this assembly may know that the Lord does not deliver by sword or by spear; *for the battle is the Lord's* and He will give you into our hands."

That thing that God has created us to do, He is the one who will accomplish it. He is the one who will provide what we need. He provides us with:

- The Holy Spirit (John 14:26)
 "But the Helper, the Holy Spirit, whom the Father
 will send in My name, He will teach you all things and
 bring to your remembrance all that I said to you."

- The Body of Christ (1 Corinthians 12:7)
 "But each is given the manifestation of the Spirit for the common good . . ."

- The Words of God (2 Timothy 3:16–17)
 "All Scripture is inspired by God and is profitable for teaching, for reproof, for correction, for training in righteousness that the man of God may be adequate, equipped for every good work."

3. Passion

We're not supposed to do these good works half-heartedly. People connected to God are driven people. They are compelled to do these good works because of the love of Christ (2 Corinthians 5:14) and to do them with great passion. " . . . who gave Himself for us, that He might redeem us from every lawless deed and purify for Himself a people for His own possession, *zealous for good works*," (Titus 2:14).

4. Purpose

"Nor do men light a lamp and put it under a peck-measure, but on a lamp stand; and it gives light to all who are in the house. Let your light shine before men in such a way that *they may see your good works and glorify your Father who is in heaven.*" (Matthew 5:15–16) Where we are right now may feel like a very dark place, but often that's just where we're supposed to be. Jesus didn't ask His Father to take us out of this world (John 17:15), but rather He has sent us to be in the world just like He was sent to be in the world (John 17:18). In the middle of the darkness, that's

where our purpose can best be accomplished. Light stands out best in darkness. We can glorify God best among darkness. There we can best let people know what God is like; there we can do those good works for which we were created and for which God has given us provision in order to manifest His excellence to hurting, broken, and enslaved people.

Let your light shine.

Do those good works.

This is what gives life meaning and purpose.

This will satisfy.

This will quench our thirst.

XIV

Conclusions

So what's the conclusion of all of this? Living life apart from God is a futile endeavor. It traps us and ruins us. The things life throws at us are just too big. We can't handle them. We don't have what it takes.

We need connection to God. We need to make peace with God. We need to believe in the deepest part of us that Jesus is who He said He was and did what He said He did. Then the thirsty, lonely bush will become that flourishing, connected tree. The vast expanse of God's provision will become available to us. This, however, doesn't guarantee winning our battles with stress. We still have to make daily choices. When life heats up, we still have to decide where to get our water.

In the middle of life's battles, it's easy to forget all of these details but a few distilled thoughts might stay with us and help us even in the hardest days.

So begin every precious today:

Remembering that we have a purpose . . .

Focusing on the very few important things . . .

Being strong and courageous in what we do, knowing God is with us . . .

Cleaning out all the junk—God can only use us when we're clean.

Doing the things we were created to do; doing the good works of showing people what God is like; showing them His love; tell them the Truth. This will bring glory to God.

This will give us peace and every day, we won't be thirsty.